5886

Alive to Art:
PORTRAYING
People and Places
José Llobera

TRANSLATED AND ADAPTED BY

W. J. Strachan

Crane Russak · New York

Portraying People and Places

American Edition 1976
Published by

Crane, Russak & Company, Inc.
347 Madison Avenue
New York, N.Y. 10017

ISBN 0-8448-0870-9
LC 75-39500

© Copyright 1970 by
Jose Llobera and by
Editorial AFHA Internacional, S.A.
Barcelona

English Translation
© Copyright 1972 by
Frederick Warne & Co. Ltd.
London

Printed in Spain

INTRODUCTION

To be an artist you do not need to be a professional painter or sculptor. What you must have is a sensitive visual response and the ability to express it sincerely. In everyday life we express ourselves through the spoken or written word. In the graphic arts their equivalents are the pencil, paint-brush or chisel etc. *Alive to Art* helps you to cultivate that response and to explore a variety of fascinating techniques.

In this particular part you will take a close look at the portrayal of man and his environment—city, country, exotic lands and outer space. Special additional features are an introduction to world architecture and a section on how to 'read' a work of art.

As your skill and awareness grow together you will acquire a new confidence and satisfaction, since each idea to be found on these pages will suggest to you a thousand other ways in which you can express yourself through art.

Studies from the outside world (familiar settings or figures, landscapes, scenes of urban life) to accustom the student to the observation of significant aspects of these subjects through the medium of line, colour, modelling.

Approach to the understanding of the problems of space (sense of volume, planes, depth). Elements of perspective as an intuitive means of contacting reality.

First steps towards the appreciation of works of art.

ACKNOWLEDGMENT

The publishers wish to thank Henry Moore for kindly allowing them to reproduce his photograph of the *Reclining Figure* on page 30.

CONTENTS

Aspects of the world

You may have heard it said about someone who draws well, 'He's an excellent artist. There's nothing he can't draw.' In point of fact artists can draw anything because their endless curiosity leads them to attempt every form that nature and man have created.

Naturally these attempts were not all made in a day. But during a life-time dedicated to carrying out representations of every type of subject, the artist builds up a mental store-house in which there are no empty spaces. Animals, trees, buildings, human expressions—they are all there.

One factor which makes his task easier however is his visual memory. You only need to draw a subject from life a single time, never wholly to forget it. Our present concern is to learn to be able to represent anything in the world we live in.

Man

The family, the most available subject

The moment we opened our eyes on the world the first thing we saw was our mother, next our father. Then our brothers, sisters, grandparents, uncles and aunts etc. People remain our most available subject, so let us begin with this most important phenomenon – man.

Above all we should realize that man is a world in himself. No other subject offers so many variations. When we say 'mother', 'father', 'brothers', 'sisters', 'grandparents', try and picture them; each one of them rises before us with well-defined characteristics.

Age

Let us start by noting the influence of age on people's faces. On the opposite page you see a drawing of a whole family. Analyse each person carefully and compare the individual characteristics. This exercise will help you when you want to give the appearance of reality to the faces you draw.

Note the influence of increasing years in people's expressions and postures. Pay particular attention to the plump little boy, the tall youth and the tired old lady, the latter with the characteristic sag of the mouth due to missing teeth.

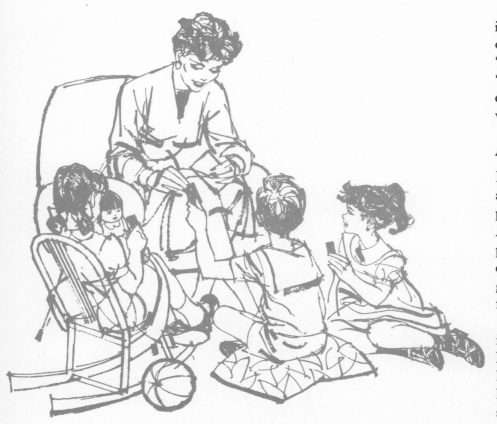

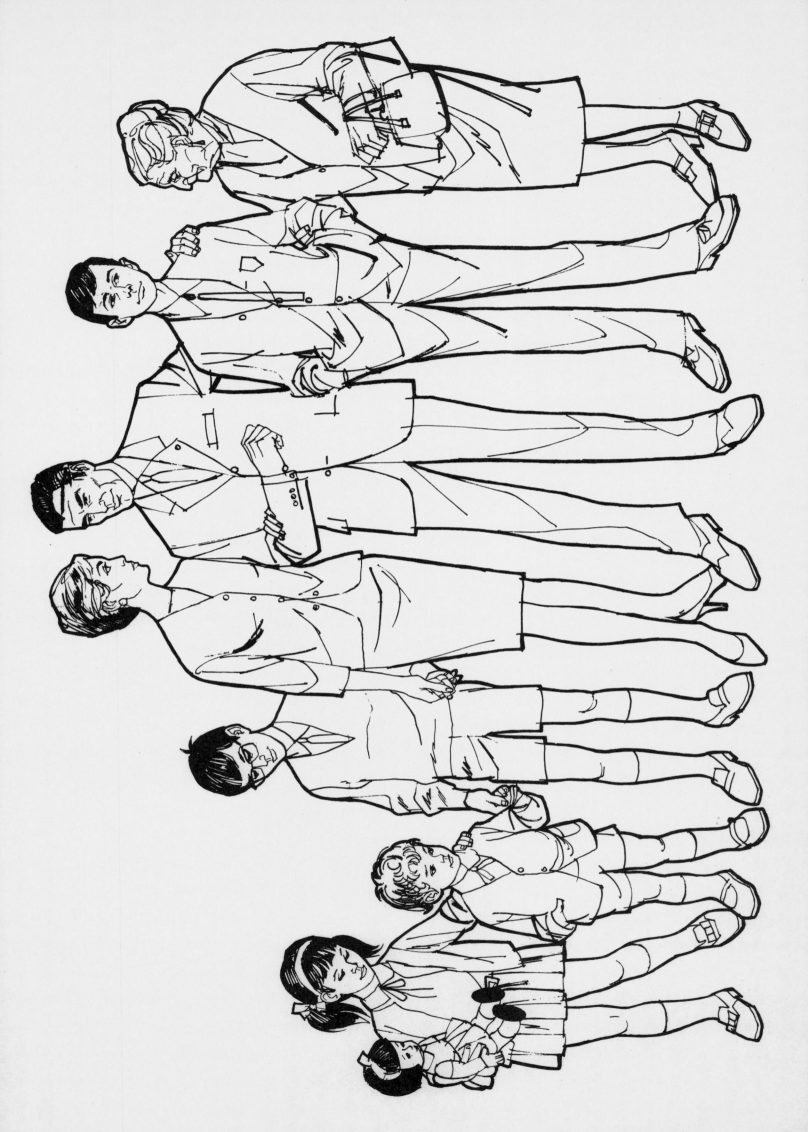

If you have time, copy the page. It isn't art, but it will help you to make mental notes of the people we are discussing.

Proportions

If you have studied the picture properly, you will have noticed the various proportions of the figures. As a child grows, each part of him does not develop at the same rate. A grasp of this irregularity is at the basis of correct representation. The head, for example, does not obey the same growth rhythm as the rest of the body; the iris of the eye does not grow at all. This is why children have such large eyes! The adult face becomes thinner, the shoulders broaden and the stomach shrinks (young children are much fatter in proportion), and many other details define a person's age.

Bearing this in mind, study the figures in the right-hand column. You will note how this partial superimposition brings out the differences of the respective ages. Note also the considerable disproportions between them, and compare the volume of the three heads in relation to the height of each person. Whereas it is an eighth part of the man's total height, in the child it is a quarter or a fifth. Having noted this, you will avoid the common error of drawing children who look like diminutive men or men with inordinately outsize heads!

Another important difference is to be found in the shape of the man's and the child's head; the man's is longer, the child's almost round.

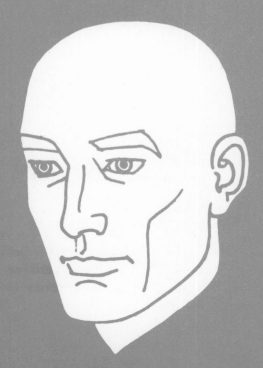

Facial disguise

The human figure is such a variable that the smallest detail can transform the expression, the character or bearing of the model, giving a clue to his personality.

Let us take a neutral face, viewed purely anatomically. On this foundation we can produce all the modifications we want merely with the aid of hair, whiskers, spectacles and a few judiciously placed wrinkles. Even if it does not seem so, the face remains constant. In fact for this experiment we have repeated the identical line-block to which we added these elements of disguise, or transformation.

In each example note the influence of the hair

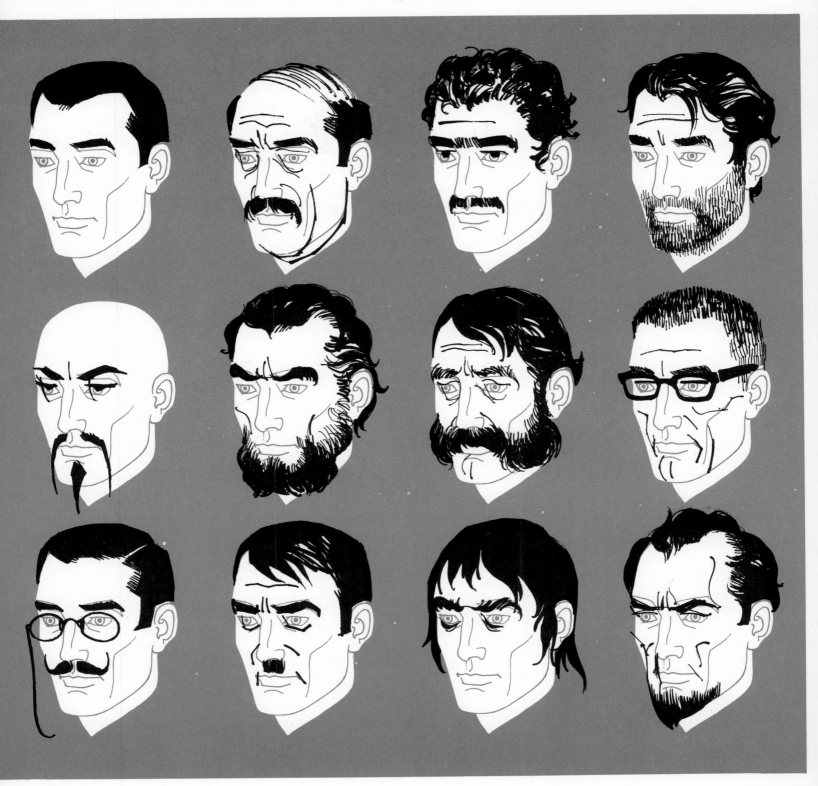

and especially how it is styled. It is a method for fixing someone's youth, old age, smartness, carelessness, aggressiveness etc. You can also place people in their particular period of time or evoke historical characters.

You should not be surprised by all this since these elements of make-up have always been used in the theatre and its successor, TV. Even there such details cannot change people's faces, but they can disguise them. Actors supplement them with the facial expression of the character they are imitating in order to put it across successfully.

We should be able to manage the mechanics of facial expression since, at this point, only two main elements are involved: **wrinkles and eyebrows,** wrinkles because they modify the facial structure, eyebrows because they are the most

effective means for indicating indignation, goodness, brutality, surprise . . . which depend almost entirely on the angle and density of the eyebrows.

Other elements of disguise are more obvious. Naturally a beard transforms a face by masking it. The same applies to side-whiskers and glasses.

'But', you will say, 'doesn't the face ever change? Is it only these elements that bring about differences?' Of course not. We have merely noted a practical device. Basically, the problem is knowing precisely how to make these differences.

Each one of you has a personal way of drawing faces, and it is a proven fact that all faces drawn by the same hand have a certain family resemblance. We shall see how to correct this tendency— almost a vice—as it prevents you from lending variety to your faces.

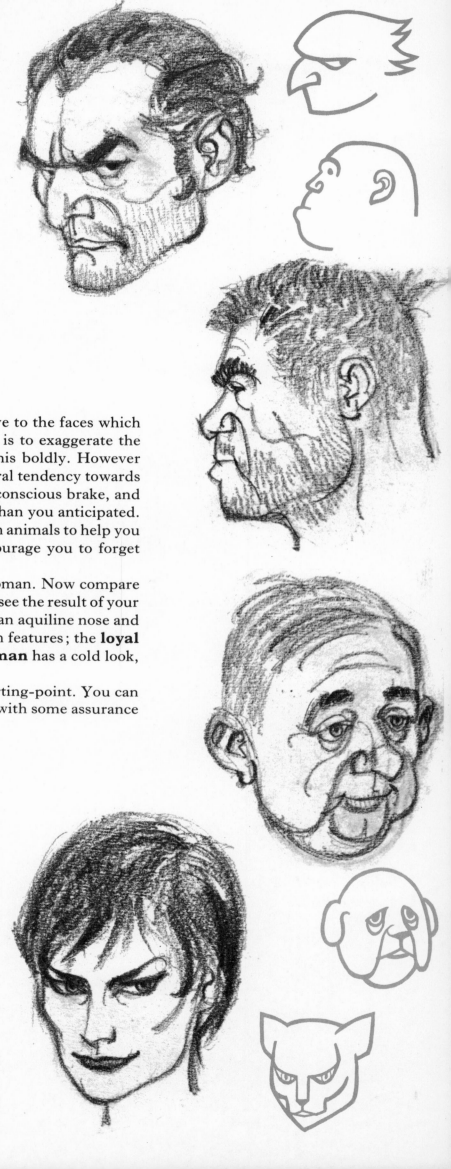

Character

You have to make an effort to avoid being a slave to the faces which your mind has preconceived. The sole solution is to exaggerate the features which determine each character. Do this boldly. However much you think you are exaggerating, your natural tendency towards keeping to normal proportions will act as an unconscious brake, and your final result will turn out much less daring than you anticipated.

A useful hint is to look for inspiration in certain animals to help you settle the character of your figures. It will encourage you to forget your normal procedure.

Note in the two insets the typical man and woman. Now compare them with the other faces more 'in character' and see the result of your experiment: the **doubtful character** may have an aquiline nose and a shifty eye; the **stupid and animal** type simian features; the **loyal** type sad eyes and canine cheeks; the **feline woman** has a cold look, hard cheek-bones and cruel lips.

You will find these expressions useful as a starting-point. You can produce an infinite variety of them on this basis with some assurance concerning the results.

Two examples of the application of facial expressions, taken from the history of art.

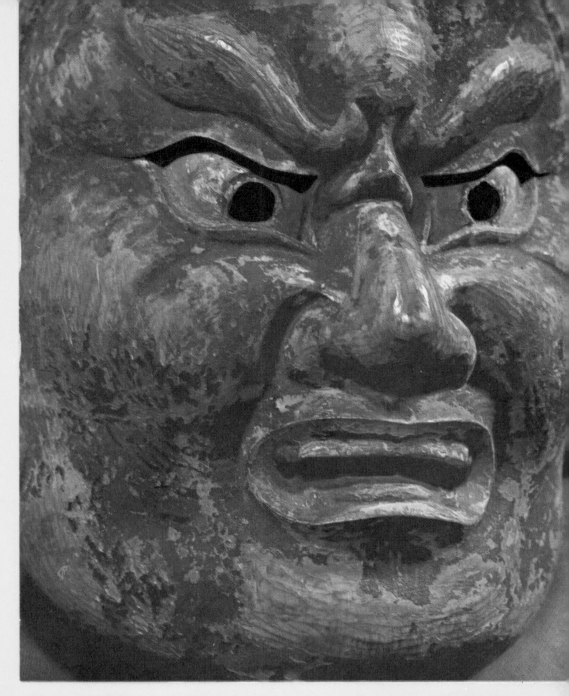

Gyodo Mask of Jikokuten
(photograph by Motohiro Taeda, by courtesy of Chikuma Shoboh Co Ltd)

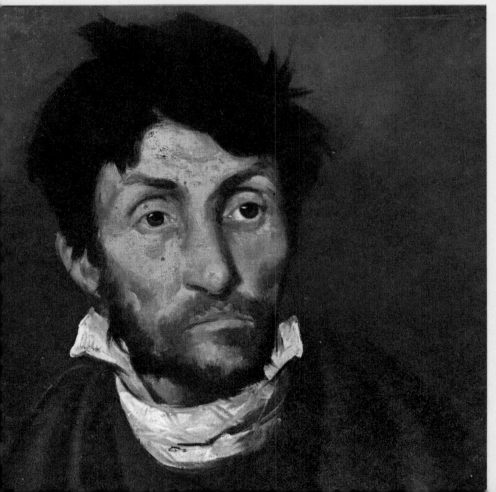

Théodore Géricault
The Mad Assassin
Ghent Museum, Belgium

11

THE BALLPOINT PEN TECHNIQUE

One minor but important invention we owe to the twentieth century is the ballpoint pen which can be capable of fluent, brilliant and clear strokes. Since its advent it has proved a welcome toy for the artist but he was at first let down by the manufacturers who thought only of accountants, housewives and schoolchildren. For them they provided

of the effects of various forms of hatching executed in biro in the eight strips below.

The drawing on this page is of two schoolboys and was executed in the most academic manner applicable to this technique. Each colour has been constructed with cross-hatchings of varying intensities. Once the pencil sketch is made, the main colours are built up but without over-emphasizing them. Only if the result seems to improve does one heighten the intensity of the colours by imposing new and more vigorous lines on the previous pattern.

four colours—black, red, blue and green—no more. Now however these pens are available in all colours, and the toy has thereby become a viable artists' technique.

Its attractiveness derives from two characteristics: variable density of line according to the pressure applied and the possibility of superposing as many colours as desired without smudging the drawing. It is true that it shares these characteristics with coloured pencils, but the ballpoint allows more subtle cross-hatching and the result is much more luminous. Look at some

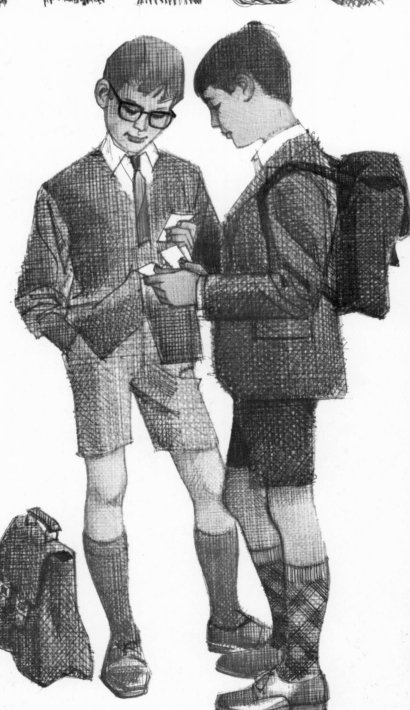

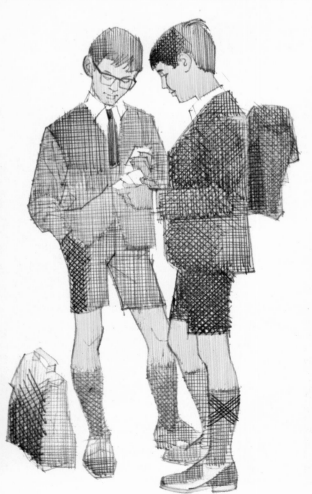

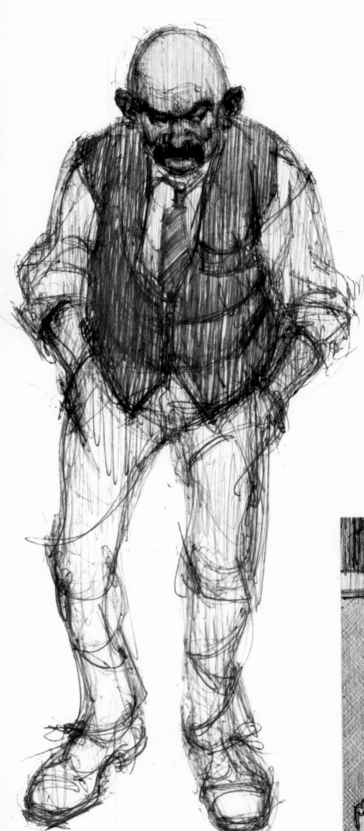

When your hand has got used to this technique you will find you can adopt a less stilted style, both quicker and more expressive. You will observe the absence of 'mechanical' hatching in the examples on this page. There is a mixture of different colours, but it occurs in irregular and limited areas.

This method allows you to dwell on some details in the subject that strike you as important and merely to hint at the minor elements. The picture on the left was executed by the author on this principle. He has emphasized the old man's nose to indicate a fondness for the bottle and he has extended the emphasis on the nose to eyes, moustache and mouth. The rest of the head is less defined. Attention is also focused on the tie and adjacent waistcoat. The other part of the figure is just a sketch, effective but intentionally vague.

Works of this kind can be striking and are quite easily done since they do not pose any major problems of construction. They depend rather on a sense of the appropriate. Don't be too nervous. The more colours you introduce—but discreetly— the greater the originality of the result.

Note the final example. It is an illustration for *Don Quixote*. A mixed technique has been adopted—neither mechanical cross-hatching exclusively like the first nor too free-style like the second. This technique is ideal for the subject since the biro evokes, however remotely, the quality of an old print. And as *Don Quixote* is a classic such a technical resemblance is very appropriate. The example demonstrates both the professional application of biro technique and its undeniable attraction.

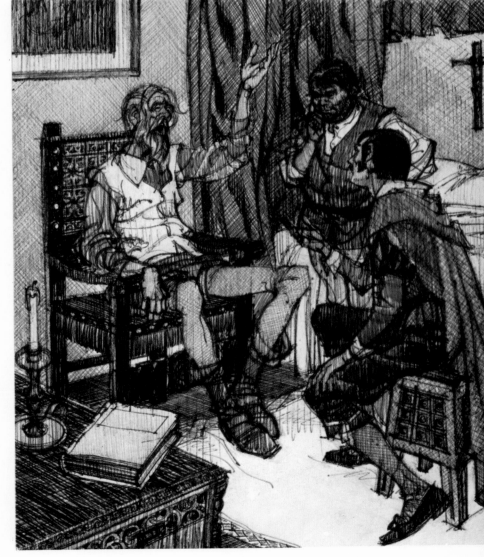

The city

The representation of the city, a question of atmosphere

A phantasmagoria of lights in New York

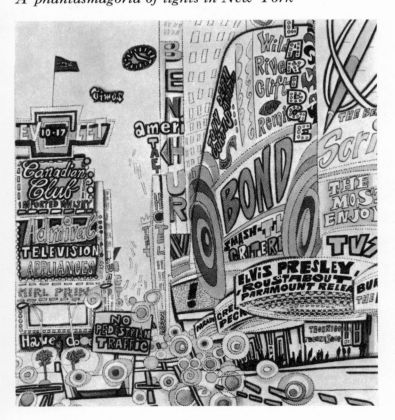

Cities have changed a great deal in the course of time. New building materials, new architectural lines, street-plans are very different from what they were. One element however is common to all periods: the atmosphere.

The city is a living organism full of movement and contrasts. Customs, clothing, means of transport constantly change. Buildings alone do not lend character to a city; it is man who inhabits, transforms and adapts it to his customs and usages. This human presence is evident everywhere: neon lights, advertisements, street-signs, window-dressings, lights, cars, people . . . such a bustle of people coming and going. Man made the houses, streets, the city: but then he himself has transformed them by his mode of life, his continual movement. In order to represent a city you have to learn how to convey this atmosphere. Houses and streets will merely be a cold desert unless you introduce the human spirit that gives them animation.

To show what I mean, look at figure 1. Does it really look like a city? Certainly there are houses, streets and pavements, but at present it is merely a collection of lifeless concrete blocks. However, we need this initial framework as a basis on which to arrange a complete environment.

The more varied the construction and the planes involved, the greater the attraction of the ultimate result.

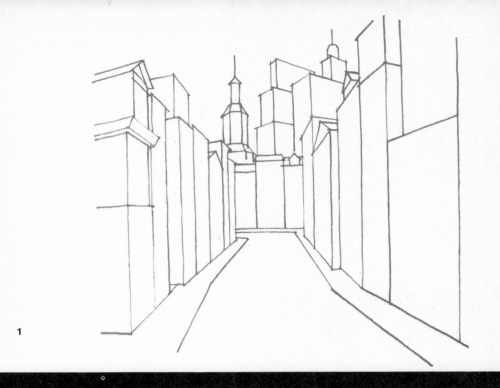

1

Asides on perspective

To draw a town or city, the use of perspective is an absolute necessity, precisely because of the variety of directional lines. To work blindly would be to court disaster.

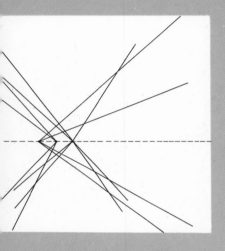

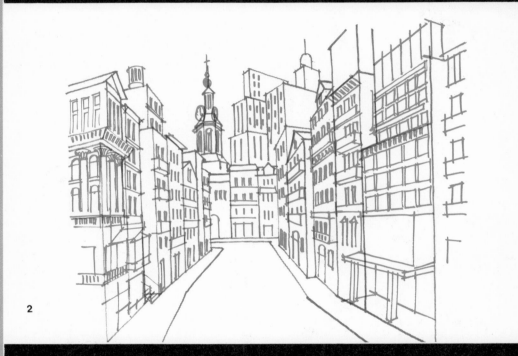

2

Note the main directional lines on which this subject is based. As you see, there are three different sets, each with their own respective vanishing points (VP's). As you know, the horizon line is common to all VP's because the artist has only one viewpoint (see page 54 in *Alive to Art : Introducing Subjects and Skills*). When you are making the final drawing forget the ruler. It is the wrist that must do the work. The perspective must not be too far out but you are not creating a work of precision.

Now add the remaining features on the initial framework: first the architectural elements, then those indicating the human presence. Do not forget that these elements must fit in within the general perspective.

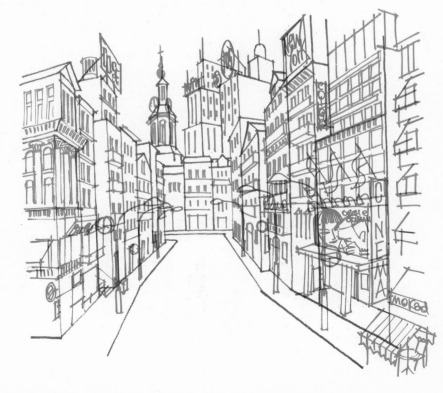

3

Finally put in the people, vehicles, lights, street signs, advertisements and fascias—everything that occurs to you. The more you include, the greater the feeling of atmosphere. But do not overdo it. Be logical and make sure the street signs tally with the traffic flow, that proportions are correct etc.

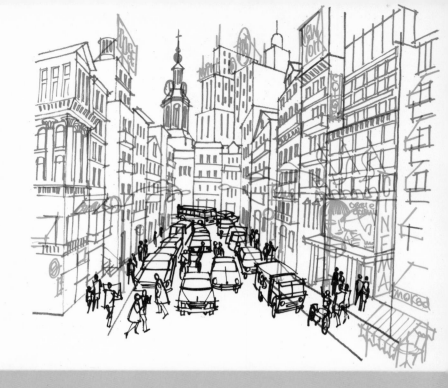

Up till now we have looked at a working plan. Now we see the drawing completed in every detail. It was started in pen and Indian ink and later brightened up with coloured inks which, because of their transparency, have not interfered with the original lines.

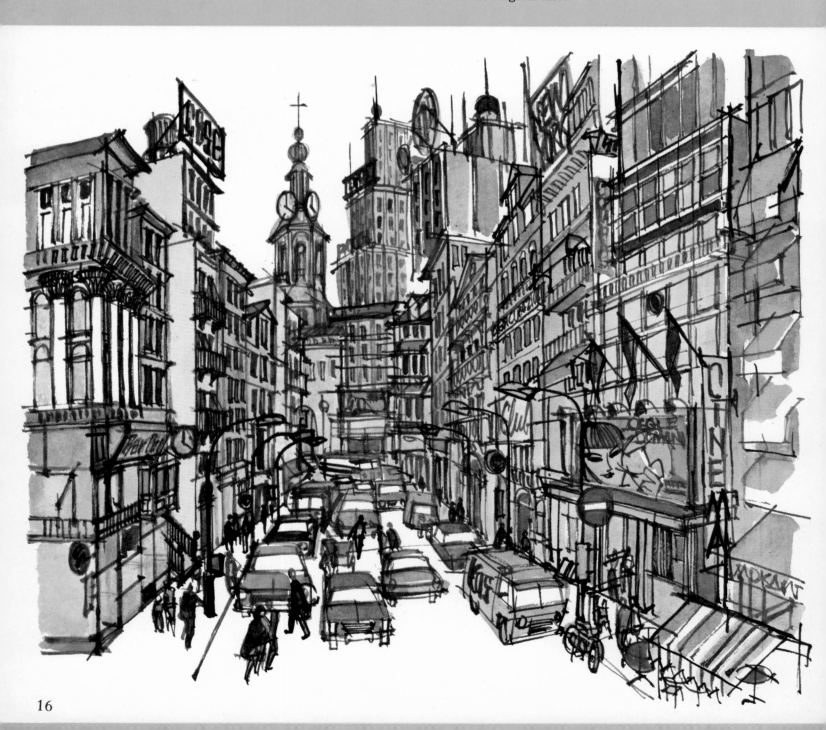

We have said that cities have greatly changed in the course of time. The art of representing them has also changed. Thus there is an enormous contrast between a city in the past and a similar one of today. And not only architecturally— although that is the most striking development—but also because of the environmental differences produced by a different way of life.

If we further take into account the contrast between the mentality of the artist of bygone times with his contemporary successor whose ways of seeing, feeling and consequently interpreting this setting are so dissimilar, you should not be surprised if their works look as if they might have been carried out by inhabitants of different planets.

These contrasts of interpretation are illustrated on this page. On the one hand *Venice*, as Canaletto, one of her most representative painters, saw her. This painting conveys the ambience of the period: the leisurely life, the festival air of Sunday, the people in the street; the whole exemplifying a society confined almost to family dimensions.

On the other hand, a vast city, as seen by the Austrian expressionist painter, Hunderwasser. The title *Blood-stained Houses* itself suggests the artist's idea and is typical of the obsessional tendencies of our society today. Where are the happy fellow citizens of the olden times when a life in common was almost the only social goal? It is true that we share life together today, but isolated, in houses and cars. It is scarcely strange then that a contemporary artist with a certain exaggeration of colours should give us such a depressing picture despite its obvious beauty.

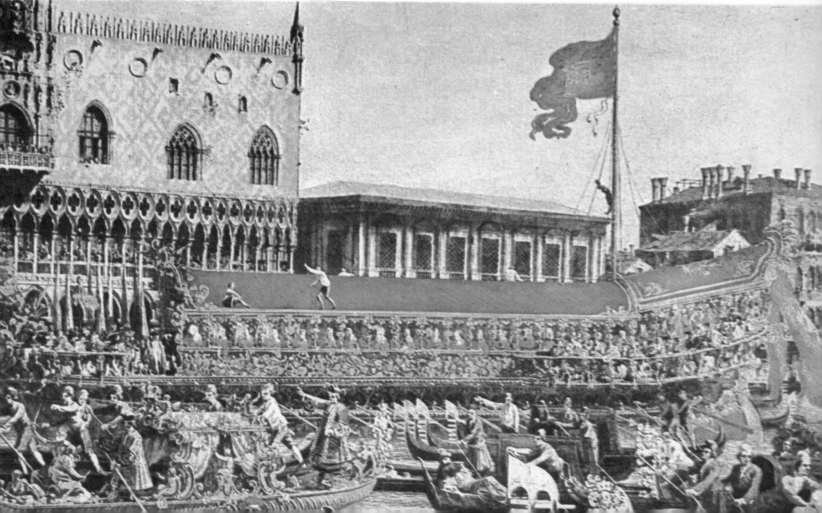

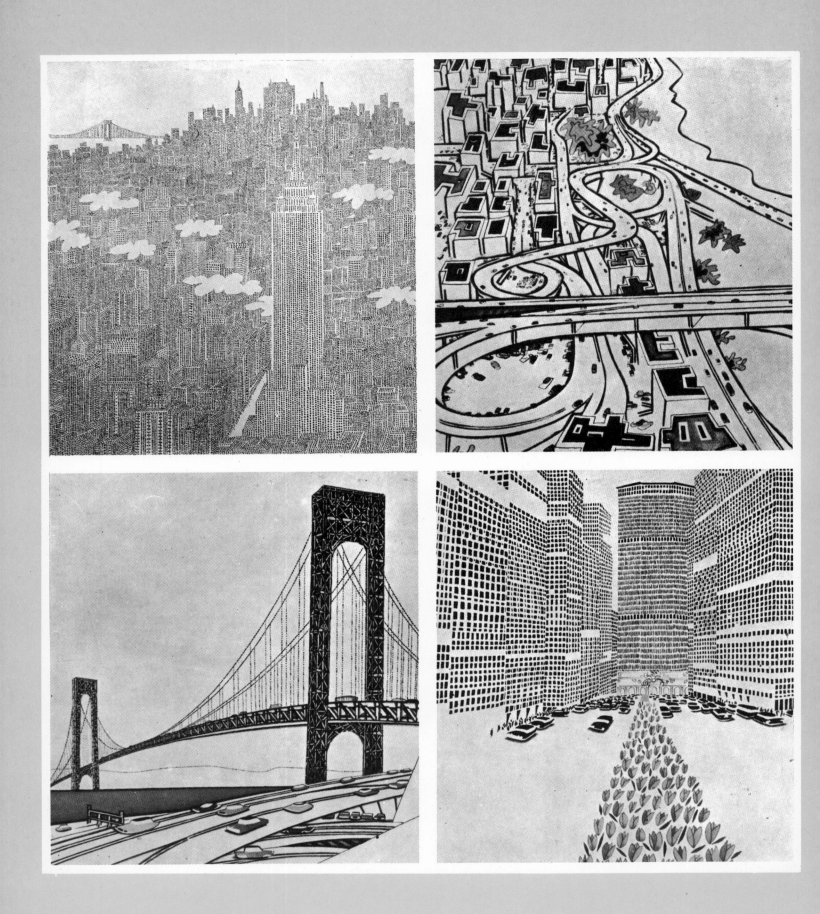

Less dramatic but equally representative of the present period are these drawings by Vladimir Fuga, similarly impressed by the striking ambience of the modern city. These illustrations (executed for SNDK publications of Prague for a text by Z. Mahler) are the fruit of impressions brought back from a journey to New York. Note the half-humorous, half-disturbing way the artist has conveyed his reactions showing great originality and force of expression.

Architecture
through the ages

The story
of architecture

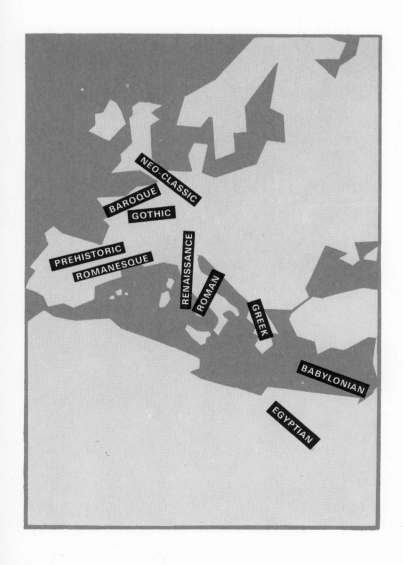

Men have evolved many architectural styles during their passage through the world. To attempt to deal with all the subtleties involved would be a lengthy business. Just think of the differences in the forms of construction which exist in Chester, Aberdeen or Bath for instance. Since each region of the same country has its own characteristics, dictated by climate and geographical situation, you can imagine the variations that exist in the whole world.

Among various architectural systems, however, some, because of their beauty and individuality, have represented real genuine styles that have endured through the ages and become part of art history. Each of these arose in a particular country, only to cross every frontier and become a general period style. Consult on the map on the left the ones we have picked out as the most important in the history of architecture. Each style is marked roughly on the countries in which it originated.

PREHISTORY

From the origins of man to 5000 B.C.

From the mists of time emerges a being who is capable of reasoning, thinking and creating ; man is born and with him the first buildings. It is the dawn of architecture.

Man's first intentions to construct buildings are to be found in the prehistoric period known as the Neolithic, or later Stone Age. Prehistoric monuments called dolmens and menhirs already point the way to the principles of culture. Man feels the urge to erect buildings and discover technical solutions to enclose a space and adapt it to satisfy a specific need.

It appears that menhirs were commemorative monuments and that, architecturally speaking, they do not represent a structural solution, since they consist only of huge boulders placed vertically on the ground. The dolmen, on the other hand, offers a major interest, being a genuine construction.

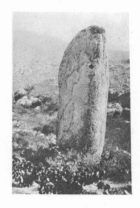

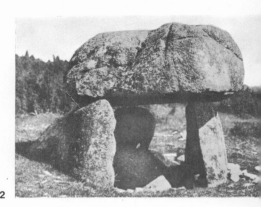

1. *Menhir of Vallvenera (Spain)*
2. *Dolmen of Crocq-en-Creuse (France)*
3. *Megalithic group of Stonehenge (England)*

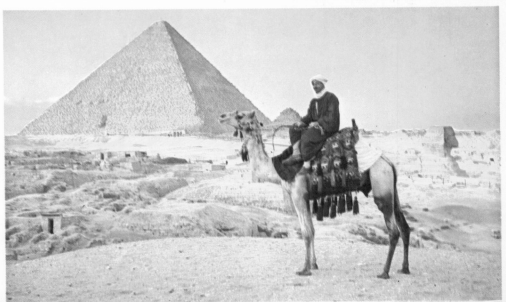

3

ANCIENT EGYPT

From 3000 to 1000 B.C.

Antiquity has some amazing civilizations to show us, such as that of the Egyptians, whose personality and spirituality surprise us even today. These great architects in their quest for immortality created a fundamental art.

The culture of antiquity which has most attracted the archeologist is that of Ancient Egypt, a deeply religious people who believed profoundly in physical immortality. For this reason the architecture is essentially religious and funerary.

We are all familiar with the pyramids which are undoubtedly the greatest expression of Egyptian funerary architecture. These huge mountains of perfectly trimmed stone are tumuli protecting the body of a Pharaoh. The pyramid formed part of an ensemble of buildings dedicated to the cult of the monarch, deified after his death. These vast tombs impress not only because of their monumentality but because of the immense amount of mathematical knowledge implied in their structure.

The finest specimens of Egyptian architecture to be found are the great temples erected by the Pharaohs of the Theban dynasty. It is in these that we find architectural styles born of a concept of beauty nearest to our own.

The Pyramid of Gizeh with the Sphinx

All the Egyptian temples, even those which the great Rameses II had hewn out of the living rock follow a similar pattern and identical structure. It seems that architects were only allowed to show their originality in the columns.

Despite its rigidity Egyptian architecture has left unmistakable evidence of a great civilization.

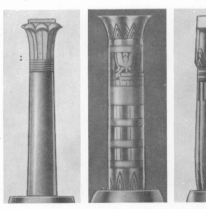

Egyptian columns based on plant ornament

The peoples of Mesopotamia, the great masterpieces of brickwork

Ancient civilizations, whose origins are lost in the mists of time, flourished in the lands washed by the Euphrates and the Tigris. These are the lands of the Ur, Abraham's homeland, Babylon and its tower of Babel, Nineveh, the great cities of the Bible.

What remains of these civilizations? An infinite number of written documents but only very few traces of their buildings for the simple reason that just as Egypt was the land of stone monuments, the peoples of Mesopotamia used bricks. Very little of their architecture survives and we know very little about it. We must not however neglect to mention

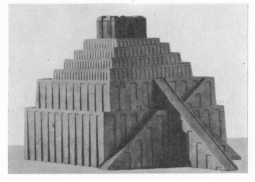

Idealized reconstruction of the Tower of Esapila in Babylon. Was the Tower of Babel like this?
Frieze of the Archers of Darius on the Palace of Susa.

one of their favourite decorative techniques in which they have never been surpassed – glazed ceramics.

The illustrations show two examples of their individual decorative style.

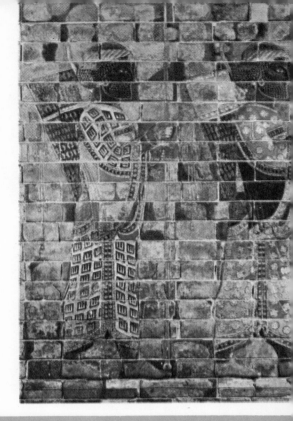

ANCIENT GREECE

From the seventh to the first century B.C.

Greek Architecture has been indisputably the greatest single influence on the buildings of all periods. Its proportions and its staggering beauty reveal a unique and inimitable art.

Greek architecture more than any other has been the major influence on all European countries and their colonies.

It provides irrefutable evidence of the logic to be found in every artistic manifestation of the Greek people. Classical architecture is the result of a reasoned system, originating from the primitive wooden temples of the pre-Hellenic period which gradually evolved towards the perfect harmony of the three orders of Greek architecture.

The Greek orders

It is significant that the history of art should have given the term 'orders' to Greek architecture. Order is the synonym of perfection. If you look at the characteristics of each order you will realize how everthing about them was foreseen and calculated. Greek art did not believe in improvisation but in logic. This is why the great edifices the Greeks built from the fourth to the fifth centuries B.C.– period of the greatest splendour – still remain today the prototype of perfect harmony. This perfection is the result of the study of proportion and distri-

bution of weight that combines function with beauty.

The Doric order

We have mentioned that the Greek orders owed their origin to traditional wooden structures. Now look at the sketch on the left. You will see an exact copy executed in marble of the original wooden columns and beam.

The temple rises on a base known as a stylobate, from which in turn rise columns without bases. These are decorated with shallow flutes separated by sharp arrises.

The Parthenon (the Acropolis, Athens)

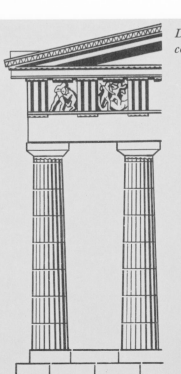

Doric columns

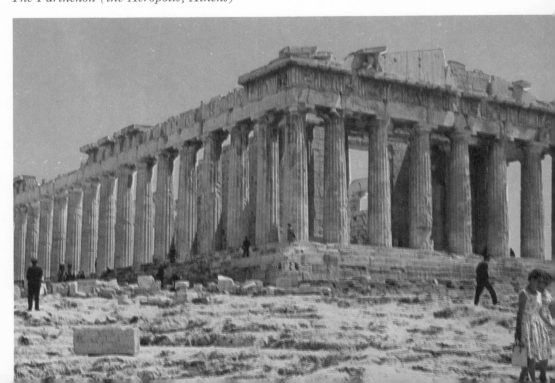

The Doric column tapers slightly towards the top. The capital is very simple and has only three horizontal elements, the annulets, echinus and abacus. The columns support the entablature composed (working upwards) of three elements—architrave, frieze and cornice.

The architrave is the horizontal beam uniting the capitals; the frieze is the decoration formed by the triglyphs alternating with the metopes. The triglyphs are fluted vertically, the slabs in between sometimes carved with low reliefs; the cornice is the uppermost element of the entablature consisting of various mouldings. It forms the rectilinear boundary of the roof. Sometimes the architrave is surmounted by a pediment—a triangular element, the purpose of which is to hide roof joins and cover terminal points. The triangular surface enclosed by the pediment, known as the tympanum, was usually adorned with low relief.

The Ionic order

This was the favourite order of the Greeks of Asia Minor. The Ionic temple rises on a base or stylobate but the columns do not stand directly on it but on a base composed of various elements.

The flutes of the column do not touch each other as in the Doric order. Instead there is the flat surface of the fillet between the flutes. Each of the latter terminates at the top in the form of a small semi-circle before the beginning of the capital. The Ionic column is made up of two main elements, spiral forms known as volutes linked by a fascia decorated by three ovolos (egg-moulding).

The architrave of the Ionic temple is

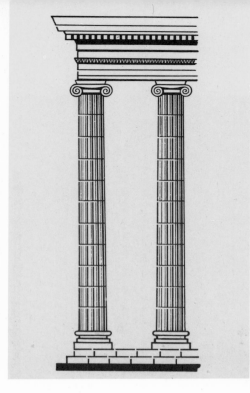

not so heavy as that of the Doric; it is no longer a smooth surface but consists of a triple fascia in three planes like superimposed beams. The decoration of the frieze shows more variety and allows a free development of a motif. The cornice shows a slighter projection than in the Doric order.

The Corinthian order

The Corinthian order is in reality a variation of the Ionic order from which it differs only in the form of its capital. It shows an irrepressible desire for decoration, exemplified in the adoption of the acanthus leaf motif for the capitals.

Ionic columns

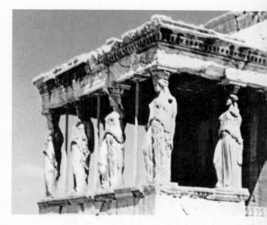

Caryatides (Athens)

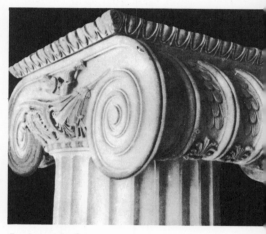

Ionic capital

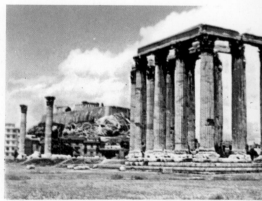

Temple of Zeus (Athens)

These are the Greek orders to be found in every example of Greek, and later, Roman architecture.

But the Greeks erected not only temples but also the civic buildings required to satisfy the wider passions of the public: the theatre and games. The vast arenas of ancient Rome and the impressive sports stadiums of today, the pride of our modern cities, are the direct descendants of Greek stadiums such as that at Delphi. As for Greek theatres, they were constructed in the open air and their layout was adapted to the nature of Greek dramatic art.

Greece and its culture represent a climax in the story of civilization. Despite the passing of the centuries Greek art still remains as a peak of artistic perfection.

Corinthian column

Greek theatre (Syracuse)

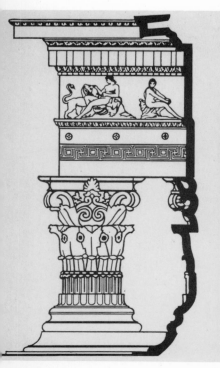

THE ROMAN EMPIRE

From the first century B.C. to the fourth century A.D.

The Romans turned their legacy from Greece to good account, transforming and adapting it to their own needs. The great engineers of Rome disseminated Roman art and architecture throughout the length and breadth of Europe.

If the essence of the Greek nation was its contribution to philosophy, the strength of Rome lay in politics.

Rome accepted Greek culture and adapted it in such a way that the art of Imperial Rome was a kind of development of the aesthetic ideals of classical Greece with a marked tendency towards pomposity and monumentality, suited to the architecture of an official character which was to become identified with the political and military strength of the first political power of the world.

But if Rome was a faithful disciple of Greece in the religious and civic domain, the maintaining of her far-flung Empire converted her into being a mistress of what we nowadays know as public works —viaducts, aquaducts, bridges, arches . . . all amazing examples of the great skill of Roman architects who indeed deserve the title of 'the engineers of Rome'.

Rome extended its political power over all the peoples of Europe and Asia Minor and made her influence felt in every corner of the known world. Her provinces and colonies vied with each other in imitation of the metropolis, and if Greece represents the seed of our civilization, it was Rome that disseminated it over the countries of Europe.

The Composite order

You will find that all the Greek orders are represented in Roman architecture. At first it will seem difficult to decide whether a temple is Greek or Roman. However, there are differences, and we find the most noticeable ones in certain capitals of the Composite order.

The Composite order is essentially a variation of the Corinthian order, con-

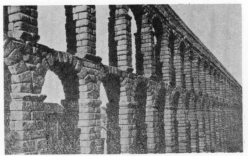

The Aquaduct at Segovia (Spain)

sisting of the addition of the characteristic volutes of the Ionic capitals to the acanthus leaves of the former.

It is not unusual to find the superimposition of all three Greek orders in one and the same building.

* * *

Rome indulged in a few developments of its own, but was adept at exploiting the lessons of the Greeks and applying them to Roman technical solutions. The round temple, for example, is almost a Roman speciality.

The arch and the dome characterize Roman architecture, not only providing a structural solution but also basic forms for the harmony of its architecture.

Commemorative and civic architecture

The Roman Empire was very proud of its prestige and those who maintained it. This is why the Romans raised triumphal arches and memorial columns with such enthusiasm in honour of their Caesars and their generals. Monuments of this kind appeared not only in the metropolis but also in the great cities of the Empire.

Like Greece, Rome also built theatres and stadiums, but the favourite spectacle

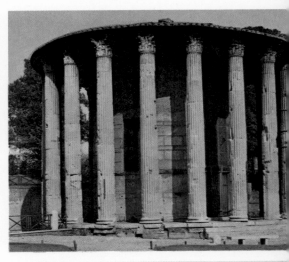

The Temple of Vesta (Rome)

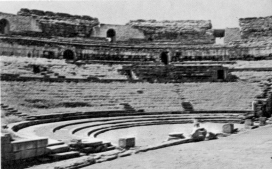

Roman amphitheatre

of the Roman people was the arena with its combats, gladiators and wild beasts . . . Every important city had to have its amphitheatre. Temples, circuses, theatres, mausoleums, triumphal arches and a great number of civic buildings were influenced by traditional Greek architecture, and, though now in ruins, are direct evidence of the pattern which was being set for European cultures in the Middle Ages.

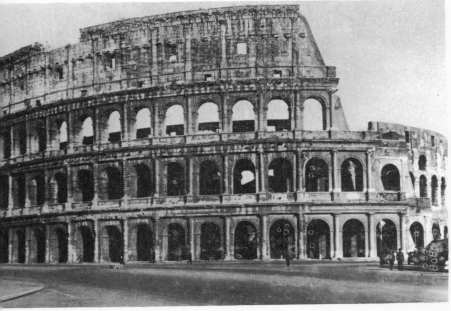

The Colosseum (Rome)

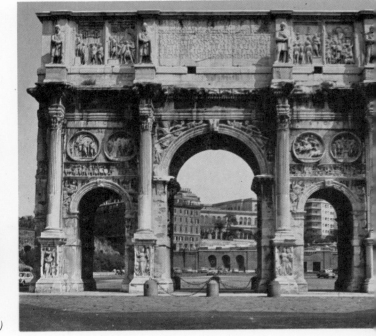

The Arch of Constantine (Rome)

THE MIDDLE AGES

From the fourth to the fifteenth century A.D.

A period of obscurity occurred in history, the so-called Dark Ages. The feudal era seems to have arrested the passage of time. Christianity reopens the highroads of art. From the severity of Romanesque art we pass on to Gothic splendour.

The Barbarian invasion spelt the complete collapse of the Roman Empire. European culture stood at a new point of departure, and the element which gave character to medieval culture was Christianity. Christian art in the Middle Ages is nobly represented by two great styles, the Romanesque and the Gothic.

Initially, the architecture of the Middle Ages seems to lack individuality. The legacy of ancient Rome is a notable factor in the architecture of this new period. The close proximity of Roman remains gave the impetus to Christian architecture in Italy. This was not the case in Spain where the process was more prolonged.

Romanesque arches (Catalonia)

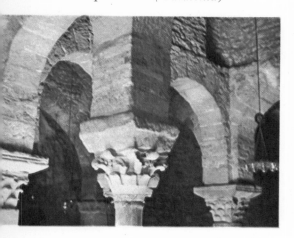

ROMANESQUE ARCHITECTURE

We must be careful not to confuse the terms 'Roman' and 'Romanesque'. The latter is the style prevailing in western Europe in the eleventh and twelfth centuries. The name 'Romanesque' conveys the fact that these western schools had based their art on that of ancient Rome.

Characteristics:

Though it is true that Romanesque architecture has structural and stylistic bases common to the whole of Europe, the fact remains that through ignorance or lack of respect the classical orders were not imitated. Each country, within the limits of constructional techniques available, built in its own way.

Only ecclesiastical buildings, especially in the eleventh century, were Romanesque. The churches were heavy structures with a nave and two or three aisles and a single transept. The arched roofs were vaulted. (When they have a semi-cylindrical form they are termed 'barrel' vaults; when they meet at right-angles the intersection produces what is termed 'groined' vaulting.) In many regions of Europe the dome (or cupola) was widely used for church roofs.

The Romanesque church required thick walls and strong buttresses. As a result, especially in places where technique was rudimentary, the area of the openings was insignificant compared with the total surface area of the walls, which moreover lacked decorative elements, except for the west front where the decoration showed great variety, depending on the place and period.

The particular characteristic of the Romanesque is the semi-circular arch; in fact the builders of this period seemed to have been obsessed by this arch, using it both for structural and decorative purposes.

The Romanesque column is a decorative rather than a structural feature, not normally having to support great loads. There are three types of capital: some are imitations of classical models, particularly Corinthian, others bear carvings of conventional animals, others again are inspired by Oriental fantasy.

The main doorways of the churches recall the triumphal arches of Rome and invariably display an element of the grandiose. Romanesque porches have markedly recessed arches with progressive narrowing of the openings produced by concentric arches diminishing as they move inwards and supported on slender columns.

Norman architecture—the English equivalent of continental Romanesque—is characterized by the following features: massive structure (e.g. the nave of Durham Cathedral), the semi-circular arch and resultant barrel vault, the rich decoration of fonts (Bodmin, Cornwall) and porches, particularly the tympanum of the latter (Malmesbury Abbey, Wilts).

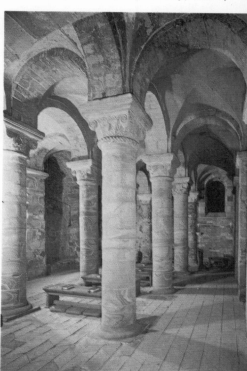

The Norman Chapel, Durham Castle (Photograph by courtesy of Picturepoint Ltd.)

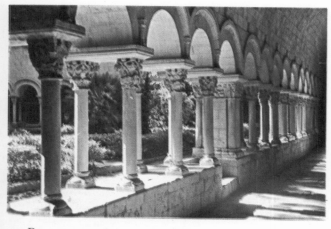

Romanesque cloister (Catalonia)

Norman doorway, Malmesbury Abbey, Wilts. (Photograph by A. F. Kersting.)

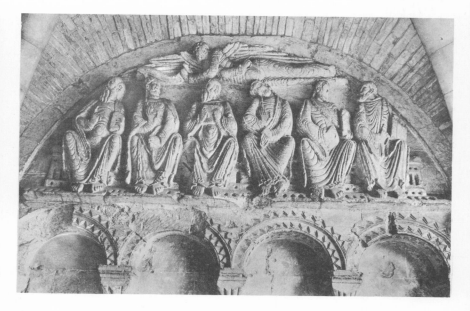

GOTHIC ARCHITECTURE

With the proliferation of Benedictine monasteries during the later Middle Ages, the Romanesque was transformed by new, bolder and more elegant forms of construction.

Gothic cathedrals have justifiably been called prayers in stone. Every part of a Gothic church seems to soar heavenwards, a movement that endows the building with a sense of weightlessness as if it might leave the ground.

Gothic is a technically perfect structural system conceived in such a way that the walls (of stone) are almost unnecessary (see below). What a contrast with the heavy Romanesque architecture!

Gothic can be said to have originated in France during the second half of the twelfth century.

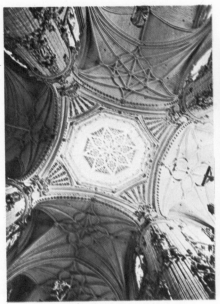

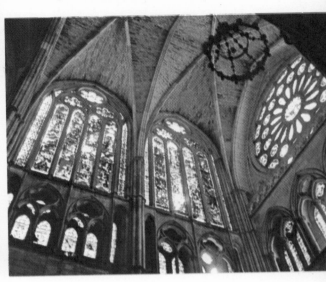

Two examples of Gothic naves

Characteristics:

Gothic arches are always pointed, reaching their climax of elegance where they meet. These arches are independent and spring from the piers like the branches of palm-trees.

The great Gothic windows create the impression of embroidery in stone, elegant curvilinear tracery held in position by slender columns that have an almost purely decorative value.

The doorways retain the characteristics of the concentric arches of the Romanesque period but they are more stylized and of almond shape.

We lack the space here to describe all the decorative elements of the Gothic style. Let it suffice to remind the reader of the extraordinary beauty of rose windows which often occupy the central part of the west front. Some of these with their exquisite proportions and lace-like tracery are genuine examples of decorative art.

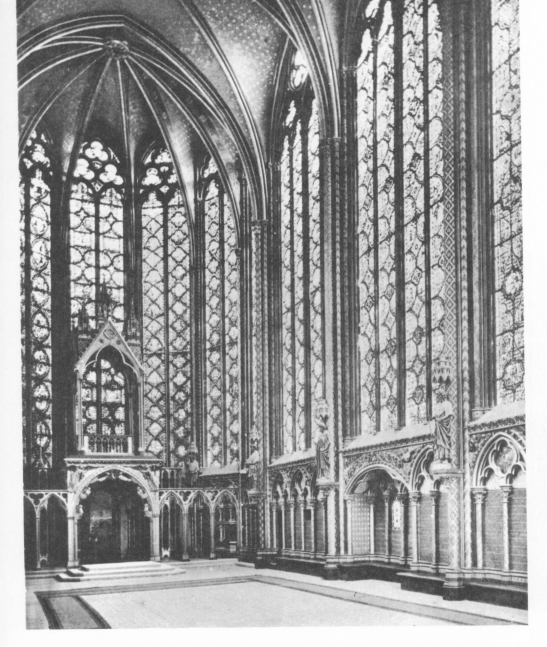

The Sainte Chapelle (Paris)

The west front of the cathedral (Siena)

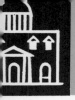

After the parenthesis of the Middle Ages one of the most important artistic movements in the history of art occurred—the Renaissance.
The architecture of this period represents the glorification of Greek art, technically, imaginatively and creatively.

The European culture of the second half of the fifteenth century gave birth to a movement of major influence in the history of art which produced its most important manifestation in Italy. This cultural movement originated in a re-assessment of the legacy Italy had inherited from ancient Greece and the Rome of the Caesars. It was a humanistic efflorescence impelling the intellectuals of the period to study and translate the great masterpieces of classical antiquity and use them as patterns of perfection.

It would however be a mistake to think that the Renaissance was merely a return to classicism. Classical antiquity was never far away but it was never merely plagiarized. The great merit of the Renaissance was its ability to learn what Greece and Rome had to teach it about the creation of a liberal art, profoundly human, capable of accepting the innovations suggested by philosophy and science.

The city of Florence was the heart of the Renaissance, enriching the fifteenth century with impressive works, of which the cathedral is one. If we pick out an individual architect of this period it must be Filippo Brunelleschi. He is the great precursor of the architecture of Renaissance Rome and a true genius, the elegance of whose buildings is unrivalled. In the dome of the cathedral mentioned, in the Cappella de' Pazzi as in all his creations we find the essence of the

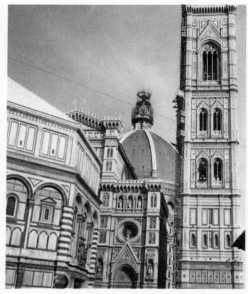

Giotto's campanile (Florence)

Italian Renaissance. The classical orders found a new justification for their existence. To Brunelleschi we also owe the first type of Florentine Renaissance palace the characteristic of which is its sobriety and the almost rustic openings with meticulously studied proportions. Prototypes of this style are the Palazzo Pitti and the Palazzo Medici-Riccardi (1435 and 1430 respectively). The latter is the work of Michelozzo, a pupil of Brunelleschi.

The work of Leon Battista Alberti represents the apotheosis of Renaissance architecture. Turning his interest from Brunelleschi's elegant simplicity, he

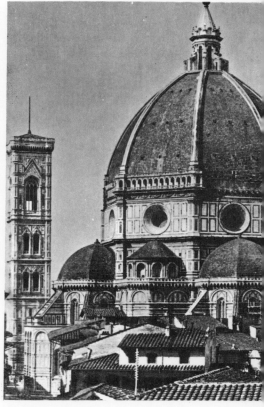

Brunelleschi's dome (Florence)

looked for his inspiration in the great thermal baths of Rome. Yet his art, though essentially Roman, shows important innovations in the field of decoration that would have been incomprehensible to the ancients. As we have already stated, the Renaissance was not content merely to imitate past achievements.

S. Maria Novella (Florence)

The Malatesta Temple (Rimini)

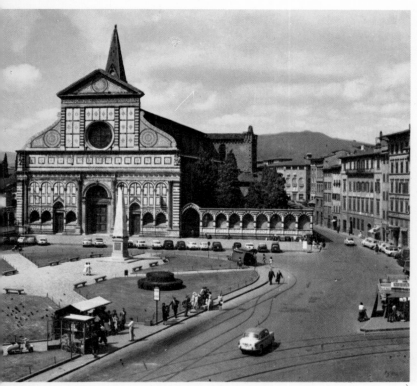

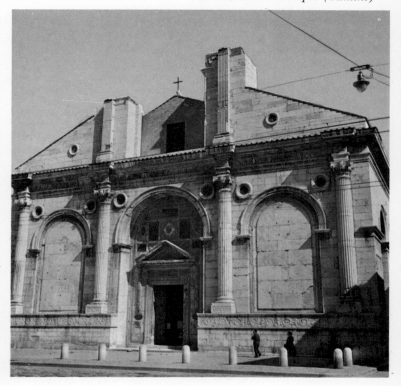

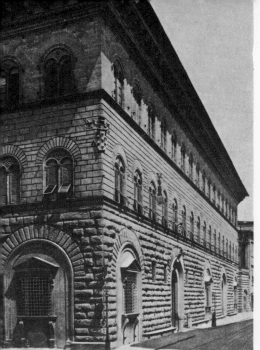

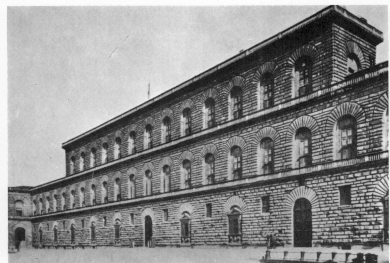

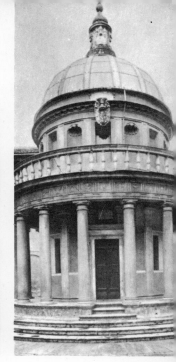

The Palazzo Medici-Riccardi (Florence)

The Tempietto in S. Pietro (Rome)

The Palazzo Pitti (Florence)

Renaissance architecture in Rome

The Italian Renaissance reached maturity in the early years of the sixteenth century, stimulated by the urge to build by the popes of Rome who, following the schism in the Church, had returned to the city of St. Peter from Avignon. Rome and especially the Vatican became a truly experimental centre where the most representative edifices of the period arose.

The Renaissance produced the type of man who has remained unique in history – the complete artist. Men like Michelangelo, Raphael, Vignola etc. have passed into history as sculptors, painters and architects of genius and skilled in all the arts.

The dome was a basic element in Roman Renaissance construction. It combined technical perfection with great formal beauty. Perhaps the most distinguished example is the great dome of St. Peter's, planned by Michelangelo and completed by his pupil Giacomo della Porta.

The ecclesiastical architecture of this period culminated in vast elaboration which conferred on it a 'baroque' appearance. We should not forget that the Baroque era is just round the corner.

The Renaissance was the cultural movement which exercised the greatest influence on all fields of knowledge. It was a time of great discovery, great ideas, of men of universal intellect, interested in every aspect of culture. Specialization never entered their minds. They were eager to embrace the whole of art. In fact it is not easy to decide whether a Michelangelo or a Leonardo should be admired more as painter, architect, scientist, artist or simply as a man.

Dome of St. Peter's (Rome)

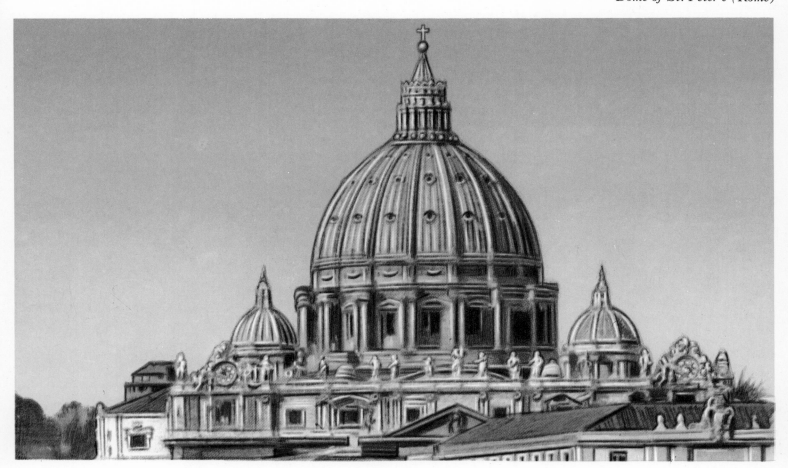

THE BAROQUE

Never has architecture been so opulent as in this period. In the Baroque we see the supreme climax of ornamentation, fantasy, structural technique. The works of this period are precious, anachronistic examples of an idiom which will never recur but will always command our admiration.

We can define the Baroque movement as an explosion of enthusiasm for the decorative elements in classical art which leads to a distortion of those elements; when, for example, a column is twisted–like barley sugar–(e.g. St. Mary's, Oxford),

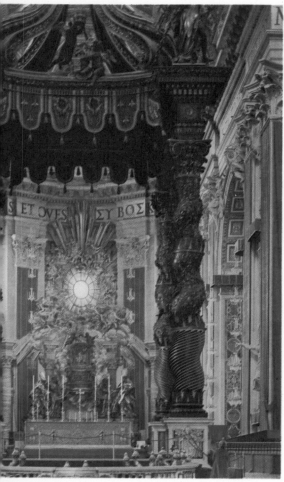

The Baldacchino of St. Peter's, Rome

thus ceasing to be the wholly vertical element its function requires, we can say it is 'Baroque'. Or when every corner of a building is filled with floral and leaf motifs, with not even the curves of its arches free of ornament, we are likewise

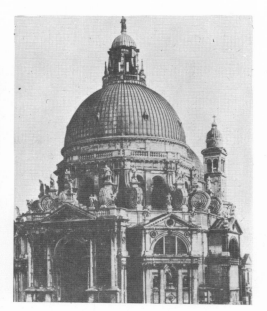

Santa Maria della Salute (Venice)

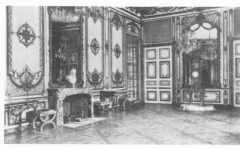

A Louis XV Interior

witnessing a manifestation of the Baroque.

It is not easy to give a precise date to the birth of the Baroque because in many phases of the Renaissance we already note details that are unmistakably germs of the later style. However, it was in the seventeenth century that Bernini and Borromini founded a first Baroque school in Italy which was to proliferate immediately throughout Europe and Latin America.

Nevertheless it was not in Italy that the movement attained its fullest expression. In Spain the Baroque was exaggerated by the Spanish architects who did not leave a single square centimetre of façade unadorned. In fact Spanish Baroque suddenly became a style of its own, achieving its finest flowering under the term 'Churrigueresque' (after the architect who introduced it). This style found its way, through Spanish influence, into the Netherlands and Latin America.

Once the Thirty Years War was over in 1648, Central Europe and Germany adopted a version of Italian Baroque. In France the Baroque give rise to decorative styles of great elegance that took their names from the reigning monarchs. Thus we speak of the style 'Louis Quinze' or 'Louis Seize'. This applies also to English Baroque in the styles known as Jacobean and Queen Anne.

Quite apart from its elements of extravagance, the Baroque is a rich and imaginative style of great beauty that presented immense technical problems.

THE NEO-CLASSICAL REACTION

Because of its very complex nature, Baroque was bound to provoke a feeling of weariness. This manifested itself simultaneously in various places in Europe. The eighteenth century, therefore, witnessed a revival of classical architecture in the so-called Neo-Classical period. The Greek orders came back into favour interpreted on more scientific principles than had been so during the Renaissance.

The Neo-Classical period is distinguished by its correctness and its technique but is patently lacking in the genius and expressive force associated with the classical orders during the Renaissance despite the fact that, scientifically speaking, the latter had not been correctly interpreted. The Neo-Classical architects tried to be new Greeks at a time when Greece could no longer be resuscitated.

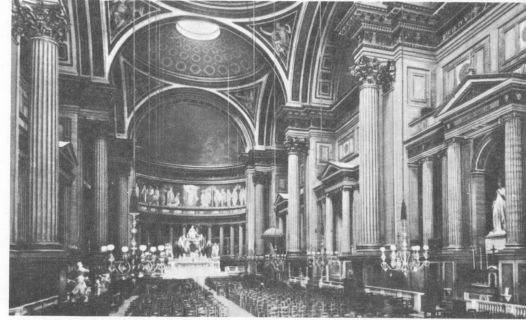

The Madeleine (Paris)

THE CONTEMPORARY SCENE

From the nineteenth century to the present

Architecture in our time has discovered its true spirit—functionalism or fitness for purpose. New materials, modern building techniques and a fresh concept of life have made a new art possible, a prelude to a new historic period.

The advent of Neo-Classicism seemed to indicate that in art (and in architecture in a tangible sense) everything had already been done. Actually, the disconcerting architecture of the nineteenth century seemed to justify this assumption. Europe felt the need for a modern idiom, and the architects made every effort to adopt every known style without fixing on any single one. The mistake of that period lay in its belief that beauty had to do with the decoration of forms or turning out architectural elements that imitate other things: a column for example might imitate a tree-trunk or a roof be covered with floral motifs.

A great advance was made when architects discovered—and they were helped in this by the culture of the period—that a form can be beautiful without needing to imitate another form and that function may create its own beauty. In our own time, therefore, a genuine art has arisen, based on the principle: function conditions form.

Beauty nowadays depends as ever on proportions and materials and of course on the structure of the building. The masterpieces of contemporary architecture are possibly more genuinely architectural in form than ever before, since every structural component corresponds

The Pirelli Building (Milan)

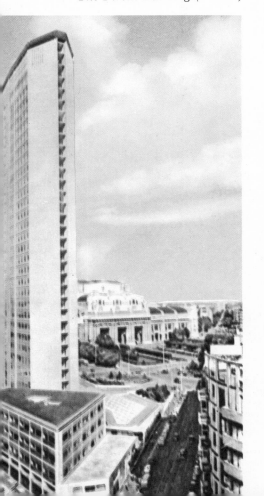

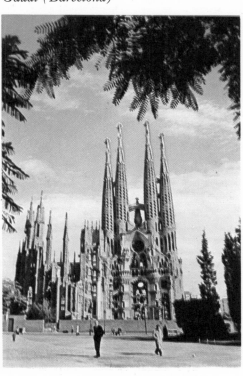

The Church of the Holy Family by Gaudi (Barcelona)

The Church of the Holy Family (detail)

to a specific function. You have all seen examples of present-day architecture. Glass, steel, concrete, with free, impossible-looking lines, thanks to technical progress and our ability to measure the resistance of materials. The architecture of our time is characterized by simple, harmonious beauty. The twentieth century has indeed discovered its own architecture and it will pass down into history as a new point of departure.

The architecture of the future

Our civilization, increasingly technical, will introduce new necessities for man for which new solutions will have to be found. And there will be good solutions, for there will always be art and artists to carry on the uninterrupted process of history.

The High Court (Brasilia)

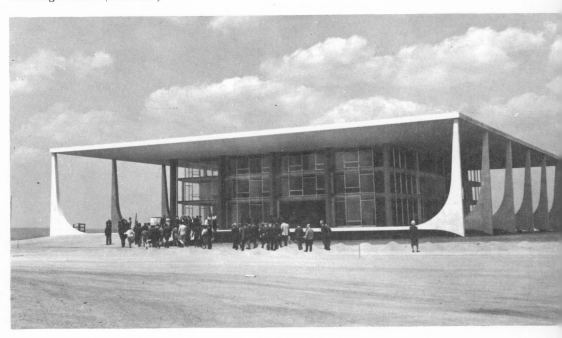

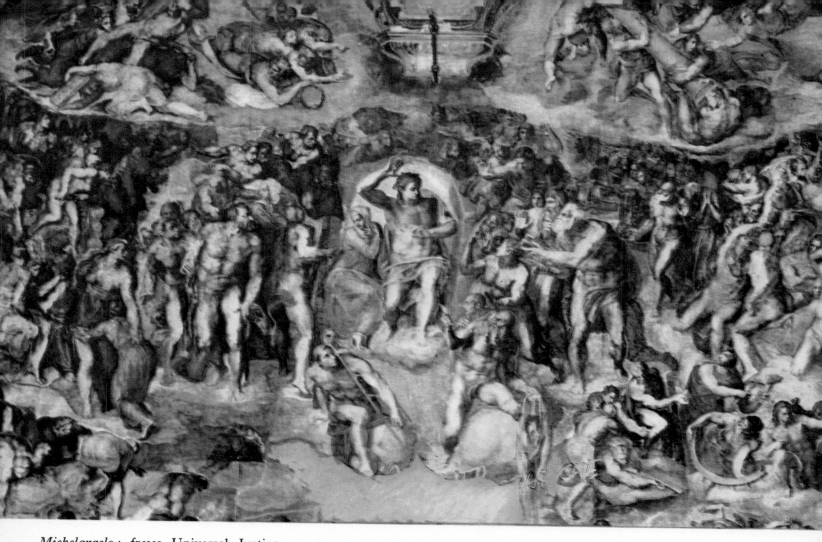

Michelangelo : fresco Universal Justice *in the Sistine Chapel, Rome*

Henry Moore : Reclining Figure, *the Unesco Building, Paris (carved in Roman travertine marble)*

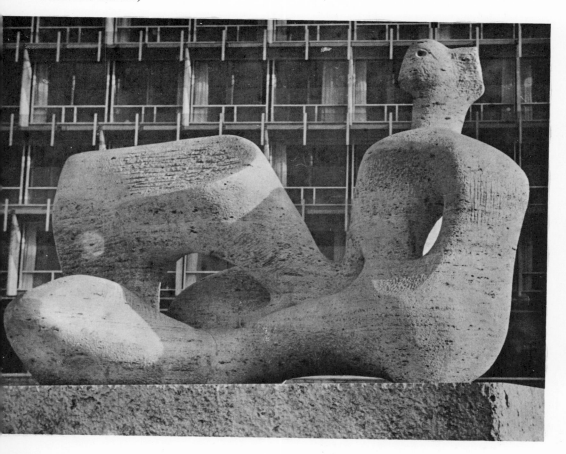

PAINTING AND SCULPTURE IN RELATION TO ARCHITECTURE

Of the three major arts, architecture is the only one which enlists the aid of the other two for an important enrichment of the whole effect. In every historical period man has made use of painting and sculpture to decorate or embellish his buildings.

Cave man had depicted on the rock-face scenes of his dangerous life. Low-reliefs are a living proof of the decorative sense of the Egyptians. The Greeks and Romans covered their buildings with statues. In the medieval times Byzantine art left a legacy of amazing mosaics, and we are all familiar with the religious carvings in the Romanesque and Gothic cathedrals. The frescoes of the Renaissance, the exuberant decorations of the Baroque and the naturalistic fantasy of Art Nouveau, no less than the decorative sense of our own period typify the great contribution that architecture has received from the other arts.

Here on this page are two such examples from two widely different periods.

Landscape

The landscape and its atmosphere

Form

Colour

Atmosphere

To a greater or lesser degree we are all familiar with the countryside. Now we need to get to know it from the artist's point of view since it is the most important source of subjects, exploited by artists of all periods.

Not surprisingly, among ever-recurring items in the landscape are houses, trees and hills. Landscape is a department of art since one important aspect of art is based on the representation of nature. The country offers us so many inviting subjects, so many colours, such variety.

Like all other subjects landscape is made up of two elements: form and colour; but there is a third element and a most characteristic one – atmosphere, that is, light, shadow, sky, aerial perspective, colours that vary with the time of day etc. It is essential to learn to represent atmosphere, for without it your landscapes will seem dead and look as though they had been painted indoors.

This then is our task. But first . . .

TREES

The landscape embraces many elements, but none is more important than the tree. We have already mentioned houses and trees in connection with landscape. We will not say any more about houses, having dealt with architecture on previous pages. So let us now study trees.

There are so many species and shapes of tree. Take advantage of your trips into the country if you live in the town and study trees on the spot. You will soon note that a tree is not the simple form you drew as a very young child, but a collection of details which will only appear attractive if we render them in a harmonious way.

You must understand the shape of the tree. Discover the main lines of growth and summarize them. Only thus will you be able to go ahead with your landscape.

The main component of the tree is the trunk. Each species has its characteristics and each bark its individual texture.

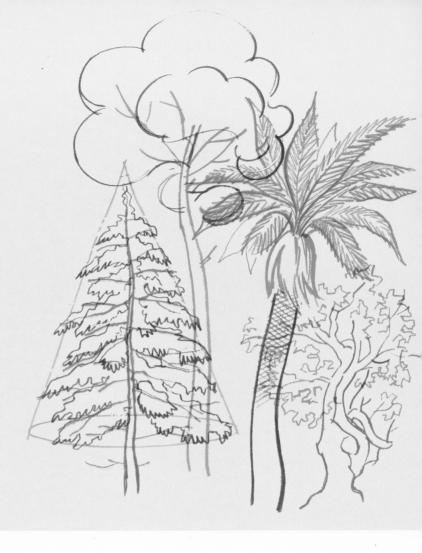

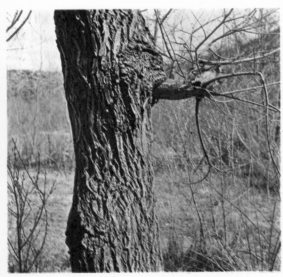

As you see, this is a fairly common type of tree trunk. Apart from light and shade, these sketch insets will give you some idea of the structure of a trunk. Note in the first the strokes which are vertical but at varying angles, in the second the effects of light and shade imposed on the original drawing of the bark.

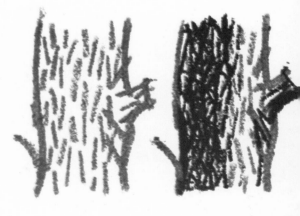

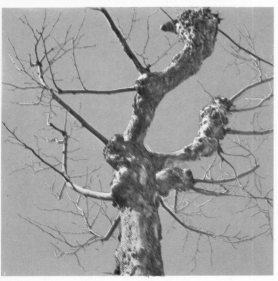

The branches are another element not always successfully dealt with, and especially the forms they take as they grow from the trunk. At this point look at the photograph and the sketch. Note the irregular shape at the top of the trunk from which the branches spring. These branches are not straight but twisted and asymmetrical. The explanation is difficult; just try to make a copy. It is the only way to tackle this subtle but important problem.

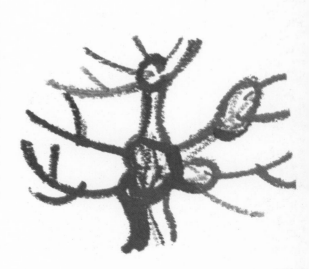

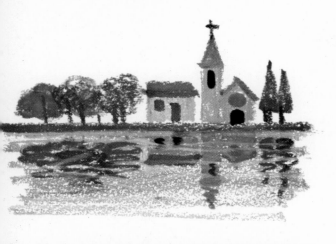

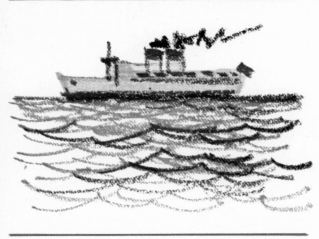

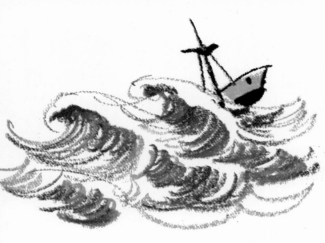

WATER

As well as landscapes, however, there are also scenes in which water dominates. These are seascapes or marine paintings.

Water is a mysterious element, chameleon-like in its changes of colour, nor is its form constant. These changes are caused by movement; when the water is still, it reflects everything around it like a mirror. Even its own colour disappears and assumes that of the sky.

Even when comparatively calm, the sea never has the stillness we note in the top picture; its surface is covered with horizontal ripples.

When the sea is rough, its appearance is very different, and the parallel strokes follow the direction of the big waves.

Ships are another all-important element in a marine painting. They present problems of perspective which we may have difficulty in solving satisfactorily.

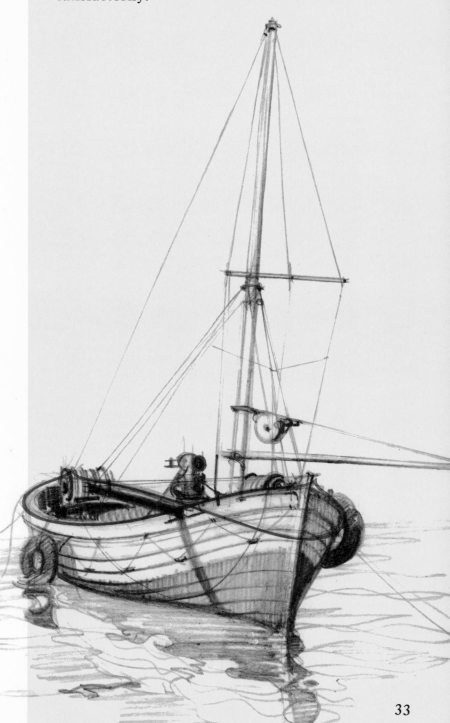

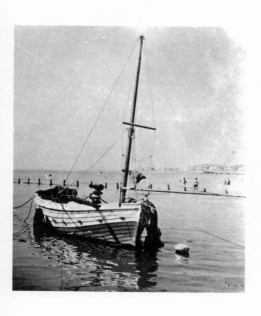

WATER-COLOUR

Some subjects lend themselves to treatment in any media but certain techniques are, of course, more suitable than others for particular subjects. When the right medium is adopted we see at once how the effects we aim at can be obtained effortlessly. The very material used as the means of expression offers this facility.

From this point of view, when considering atmosphere, water-colour is the ideal medium for obtaining 'watery' effects—rain, wet streets, mists, sunsets . . . The transparency of water-colour also helps us to represent clouds, the smoke of steamers . . .

So let us now look at this subtle technique which is not difficult, and which offers us a whole host of possibilities.

First contacts with the technique

Water-colour is not only a kind of colour, it is also a technique. To carry out these first experiments, you must provide yourself with water-colour paper. This has a roughish surface and is heavily sized so as to resist dampness. Further requirements: jar of water, porcelain palette and a rag for drying your brushes. It is a good idea to pin the paper down on a drawing-board to counteract the tendency to cockle because of dampness. The colours should always be diluted with water and never used directly from the tubes.

Having settled this, we can now go ahead.

The two aspects of water-colour

This medium possesses two qualities which we should exploit:
— The ease with which the colours can mix while still wet.
— The tranparency of colour superimposed on a previous (dry) colour.

Let us be more explicit: when we work on dampened paper, any colour brushed on to another runs slowly into it, giving a perfect 'sfumatura'. If an area of colour is painted next to another, still damp, the colours will run where they meet and produce a

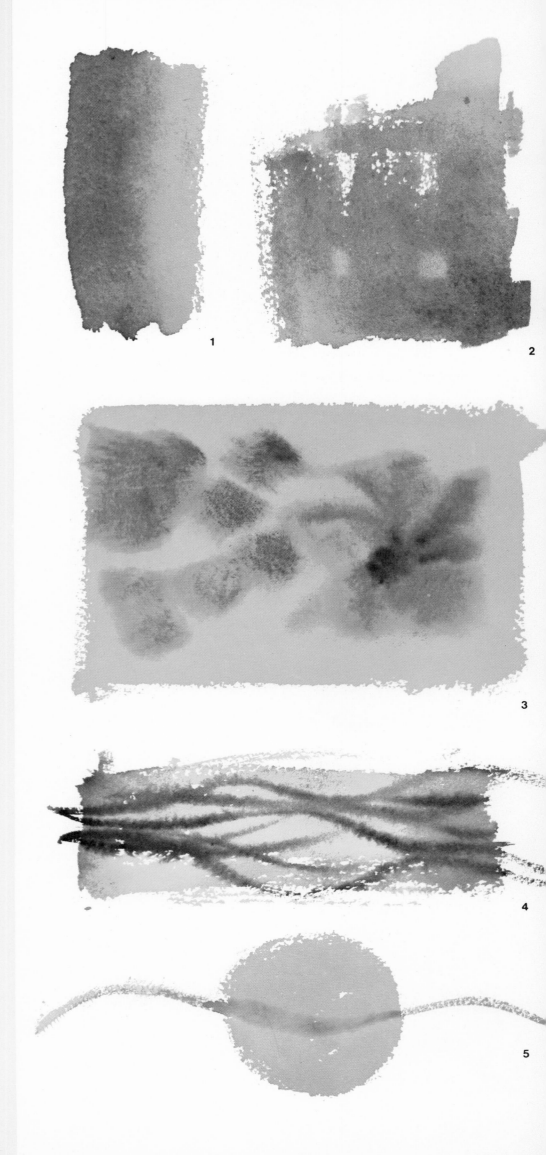

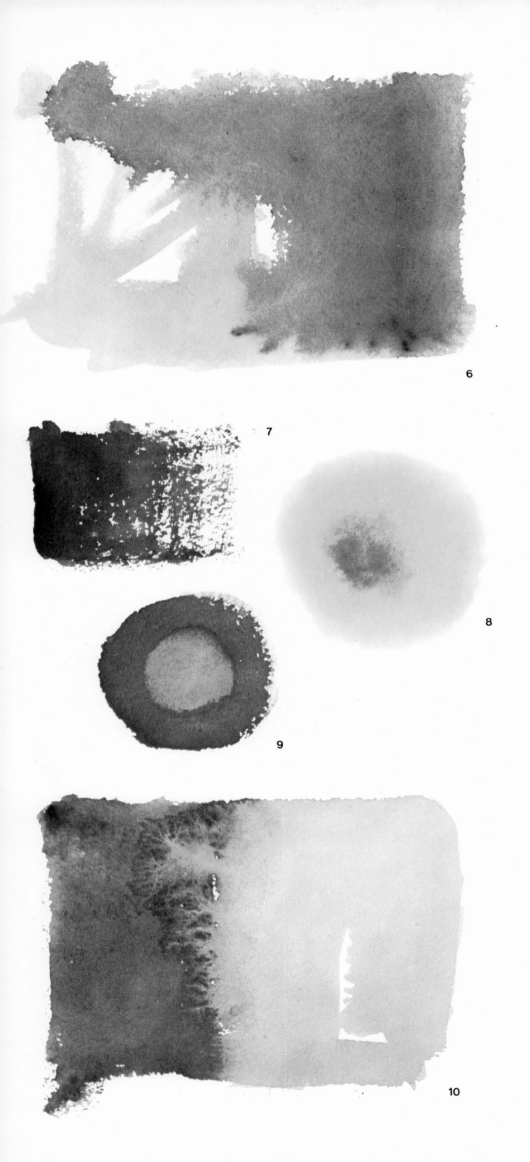

6

7

8

9

10

sfumato area which will spread according to the degree of dampness of the paper. So we work with colour of varying dampness to obtain the effects desired.

On the other hand, if we want to exploit the other quality–transparency –we wait until the colours dry so that we obtain a mixture of colours instead of the transparent effect.

These techniques are usually used in conjunction. The painting should not be wholly sfumato. Thus for certain details we need to wait until the first colour has dried. There is a wide scale of intermediate possibilities to explore between the two techniques. With this in mind, let us examine some experimental applications of water-colour:

1. *Simple exercise in gradated tones, washing one colour into another.*
2. *Dry superimposition: note the transparency of the colours where they intersect.*
3. *Applications of colour to a damp ground. Note the curious sfumato or moiré effects.*
4. *Thin brush strokes on a coloured ground.*
5. *Note how thin lines of colour become diluted as they cross the still-wet area of colour.*
6. *An example of the combination of wet and dry techniques.*
7. *An almost-dry brush. The rough surface of the paper is responsible for the nearly dry tone variations.*
8. *An explosion of colour in the centre of a very wet surface.*
9. *Removal of colour on a damp surface, with the aid of a clean, dry brush. After several strokes the colour is extracted from the desired area.*
10. *The meeting of two areas of colour-wash. Note how incalculable the effects are.*

This is only a beginning. You can now carry out many similar fascinating experiments yourself.

Let us now pass on to the most important aspect of this experiment. You will have noted that these examples have been very elementary–the water-colour itself has done practically all the work. You will have observed the interesting effects obtainable with a few brush strokes. You should now exploit the special characteristics of this medium. Look again at figure 10. Turn the page in every direction until this pattern suggests something–a wood?–the depths of the sea? It is all a question of imagination. With only two colours and three or four brush strokes you can obtain a very rich effect, and by adding a few details you can represent a whole host of things. The effects are due to the medium. Exploit them to the full.

Since even casual brush strokes take on some significance, you can imagine the results possible when they are purposeful.

Water, the degree of roughness of the paper and the colours combine to produce such rich effects of gradation that make water-colour an essentially spontaneous art. A few brush strokes and the work is complete. Indeed, if we overdo it, the work is prolonged and the result will be disastrous. Water-colour needs freshness, a sure touch, spontaneity. It is either an immediate success or it is better to tear up the result. There is no half-way.

Look at the trees on this page. They have not been any more painstakingly executed than the previous examples, but this time there was an objective. Actually these trees are virtually examples of colour-wash. If they look like trees, it is thanks to the medium.

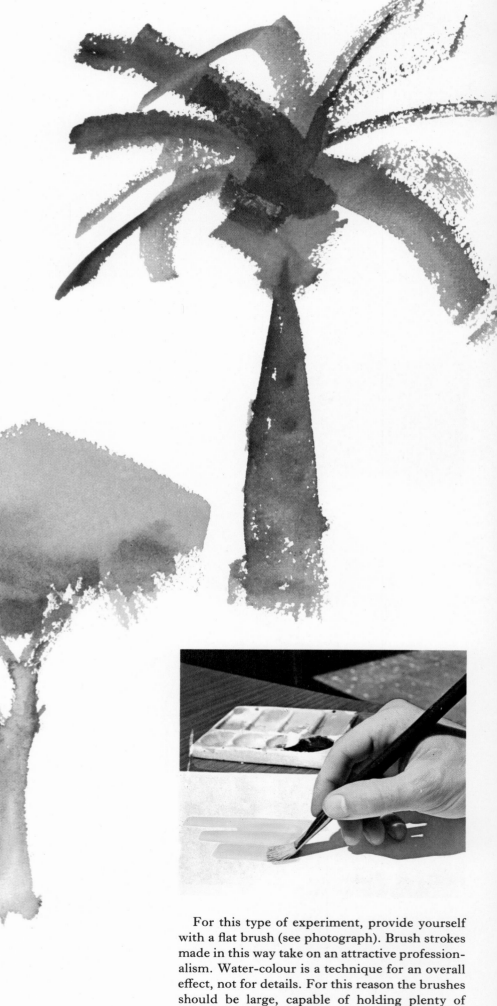

For this type of experiment, provide yourself with a flat brush (see photograph). Brush strokes made in this way take on an attractive professionalism. Water-colour is a technique for an overall effect, not for details. For this reason the brushes should be large, capable of holding plenty of colour and spreading it over the paper in broad, uniform sweeps.

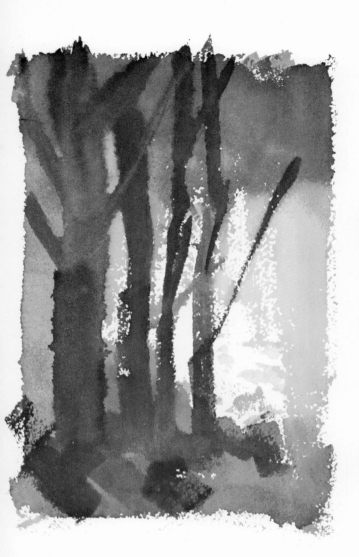

Let us continue the experiments. Now we have a more positive aim, the effects are more deliberate although, technically, still very simple.

You have only to look at these two landscapes to appreciate the total absence of detail. A few brush strokes less and the landscape impression would disappear.

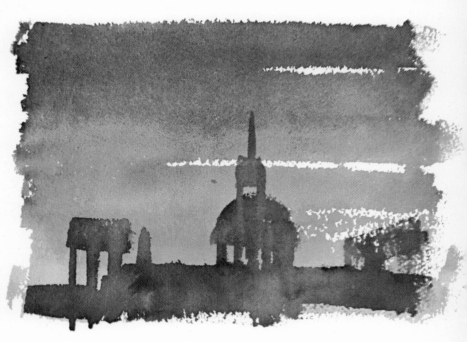

In this subject the path that winds towards the castle was produced by removing the colour with a dry brush. It can produce a useful effect but the process should not be overdone.

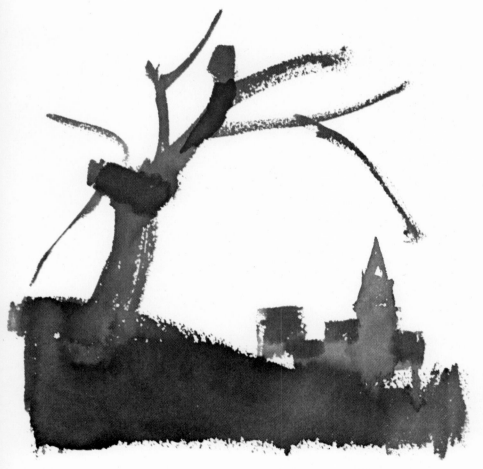

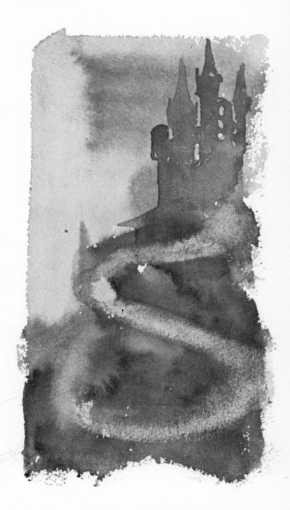

And here is a more elaborate example. Over and above water-colour characteristics, it shows how particular effects are obtained by the way the colours are applied. A step further and we shall pass from the simple experiment to the real water-colour painting.

Finally, here is a water-colour composition. As you see, from the technical point of view it differs very little from the previous examples. If in fact you hold this marine painting a little distance away, it will appear much more elaborate than it really is. What matters is not so much the details that fill the work, but the purpose of the brush strokes and colours.

Looking at it closely, what does the picture consist

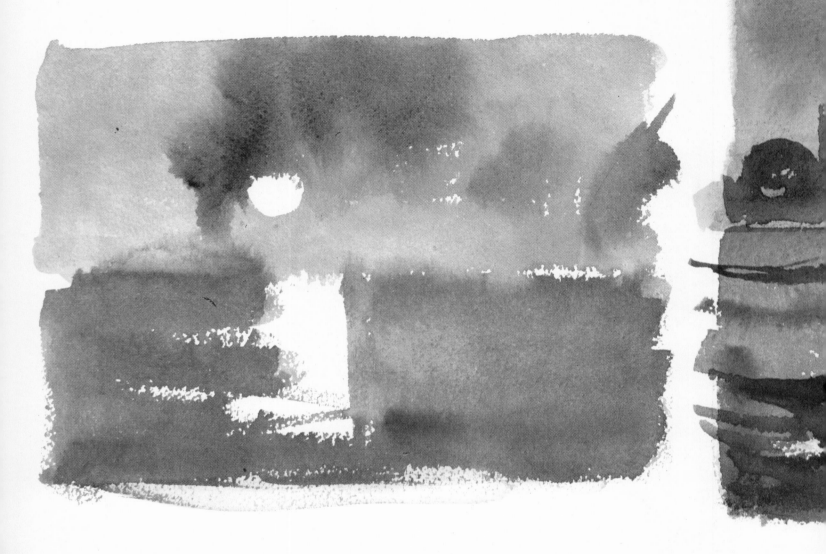

of? Three or four main effects which create the atmosphere of the whole. Naturally a setting is needed as a starting-point. In the present case it was not difficult to evoke it: on the one hand, the sea—the sun's reflections left to the blank paper—on the other, the sky with the various colour-washes which provided the tonal contrasts. The latter created the atmosphere as a framework for the various other elements. These have been given more or less detailed treatment and it is these brush strokes that bring the marine subject to life.

Of course the degree of finish in a water-colour depends on the artist and the subject. Nevertheless, spontaneity is the characteristic of this medium. If your result does not come off straight away, scrap it and start afresh.

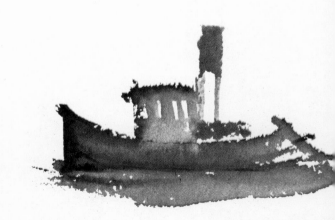

The tugboat can be painted in a very few colours. To give it a little atmosphere, you can allow the colours to run into each other. These will be carefully gradated in the final result.

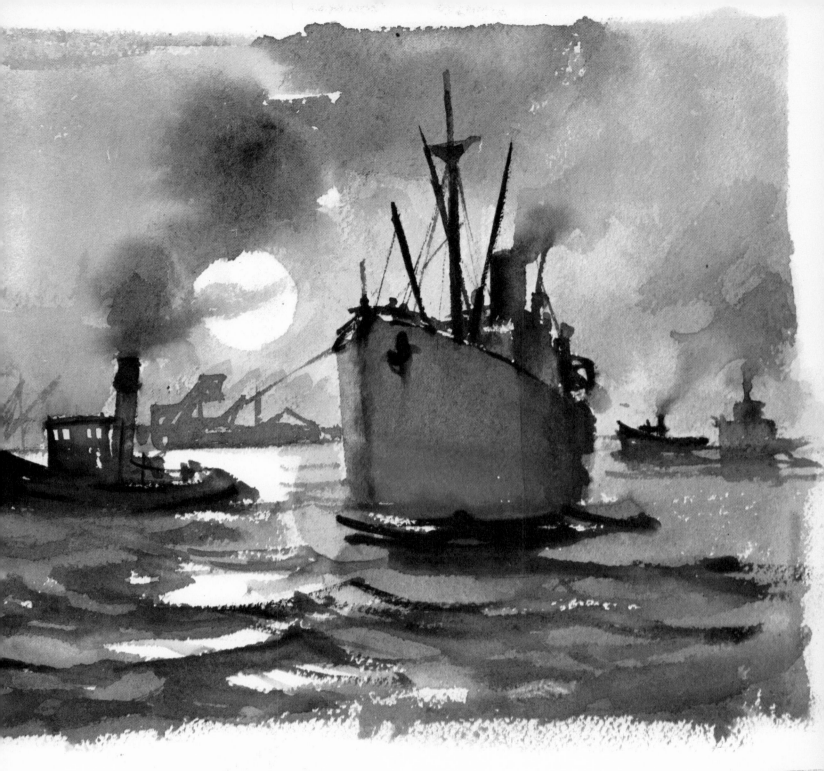

Water is one of the easiest things to represent. You have to alternate between washes and the dry brush, using various tones of green and blue to produce a satisfactory result.

Finally, we come to the main subject— the steamer. Note how we define it with a few colours and how the water-colour quality is exploited in the areas of sfumatura.

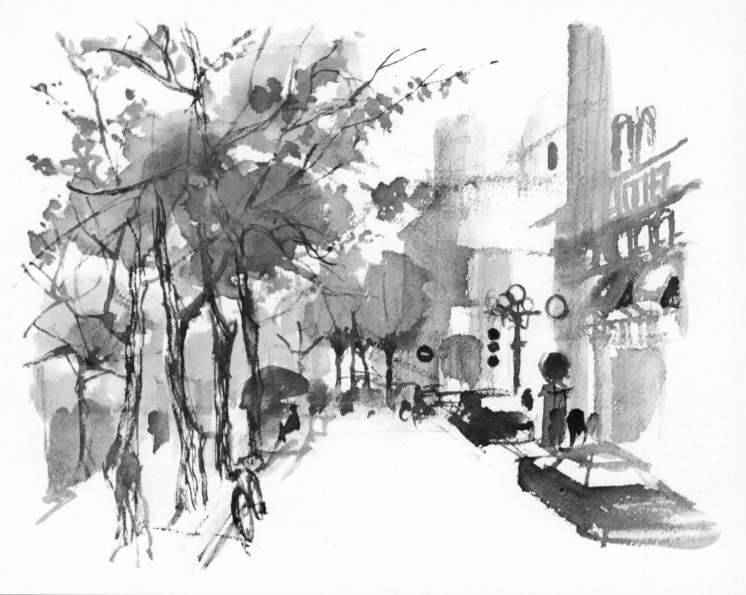

The adaptability of water-colour to other techniques and methods

All artists do not like water-colour. Many think of it as a minor art without knowing exactly why. Doubtless these critics dismiss water-colour as a technique of effects—nearly always the same—which in view of its characteristic mode of execution, allows little variety.

The water-colour is the technique for the rapid sketch, atmosphere, grace, subtlety, impression . . . Yes, impression! Not strength, profundity or expressiveness. And this is logical enough; the brush stroke that takes little account of details, concrete forms, calculated effects is too rapid, fleeting, daring. Yet its whole attraction lies in this suggestiveness which requires considerable skill to evoke.

On this page we show an example of townscape, freely painted, which still awaits the final touches. The trees, the real subjects, are treated with ample, almost exaggerated freedom of colour, but the effect is certainly original.

40

**Water-colour
with ink**

Sometimes a water-colour can be more effective when combined with other techniques, especially when they can contribute their precision and degree of finish, a quality which the water-colour by itself lacks.

One such complementary technique is the line-drawing in pen and Indian ink or pencil or biro etc. In this way all the details requiring a certain precision can be added. The example below shows a suitable use of this, since a townscape presents a number of architectural details which demand a degree of concreteness.

The water-colours on the previous page are merely intended to supply light and colour to the subsequent pen-drawing. Hence the apparently excessive freedom of the water-colour element and the strong colours of the foliage. We knew as we painted that we should be following this up with pen-drawing. In such cases since the pen lines tend to cover the colours, partially at any rate, we had to emphasize their intensity.

In producing this kind of subject we must not fall into the error of thinking that it is a matter of superimposing a line-drawing on a water-colour. Both techniques should take account of each other. The water-colour should not be 'finished', nor should the lines cope with all the forms. They should be complementary so that there is no question of superimposition, but merely a unified drawing involving two techniques.

Look at the completed picture and compare it with the one on the previous page. The water-colour part is the same but the style has been radically changed by the superimposed drawing in Indian ink. It shows a convenient and effective combination.

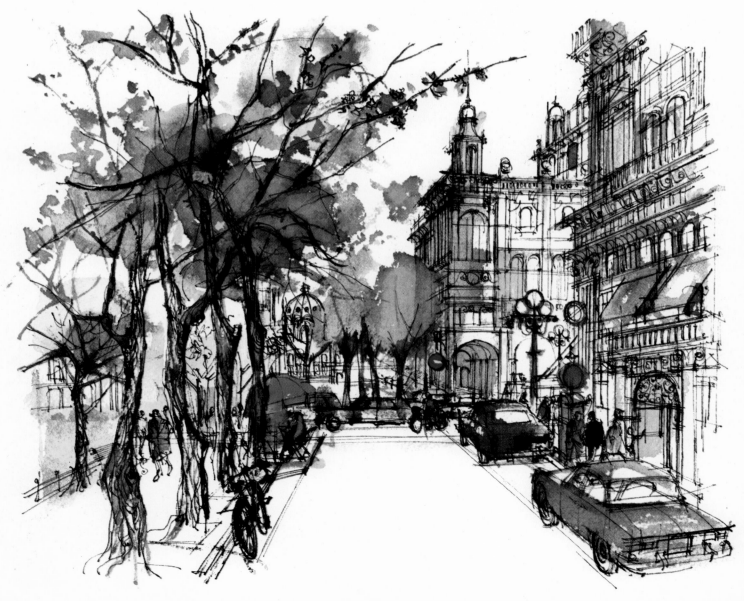

Indian ink can be used not only for line-drawings but it can also be satisfactorily diluted with water. This enables us to obtain various attractive and transparent grey tones. Their characteristics are similar to those of water-colour with the difference that with ink every brush stroke dries rapidly. You must therefore be very careful to see the grey does not dry unevenly since there is no way of rubbing out or correcting the result.

Under the heading of landscapes and marine paintings, note on the left a variation on the theme—an underwater subject. Its originality and the transparency of the greys are the chief attractions.

Two colours

The previous example was in monochrome; this one is two-coloured. Aesthetically its lack of sparkle limits its use but as the reproduction involves only two colours it is economical for book illustration.

However, with two colours we can obtain a considerable variety of tone and sfumatura according to how they are mixed. The present subject was particularly suited to this technique because its special atmosphere was in keeping with such sober tones.

In connection with atmosphere, note the different planes of the illustration; the more distant the details, the lighter the tones employed. The cranes in the extreme distance are only just distinguishable. Make the limits clear and you will always produce a feeling of reality.

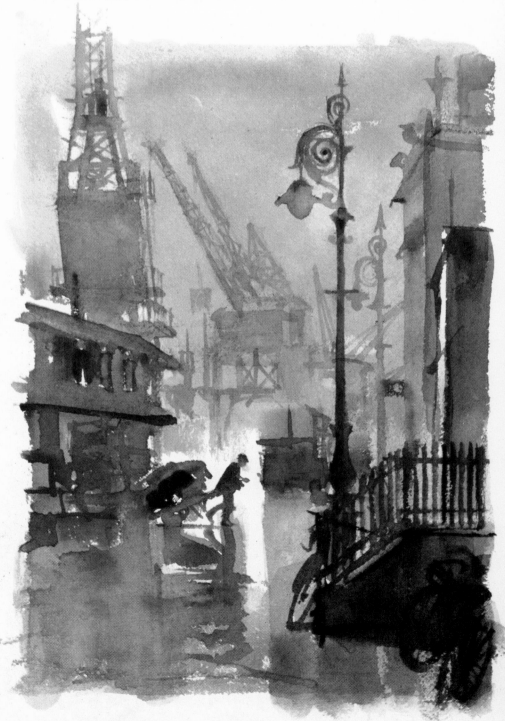

Painting
on coloured paper

You require gouache (or poster-paint) for this kind of subject because it covers the paper more effectively.

You must work on the principle of choosing the coloured paper that is most in harmony with the background of your picture. This will also ensure that your colours will be harmonious and create an attractive feeling of unity.

The three examples on this page have been done on three different coloured papers. Although the style of painting is the same, each subject retains its individuality.

A very similar effect can be obtained by first covering the paper with a chosen colour, allowing it to dry. Then proceed to paint your picture.

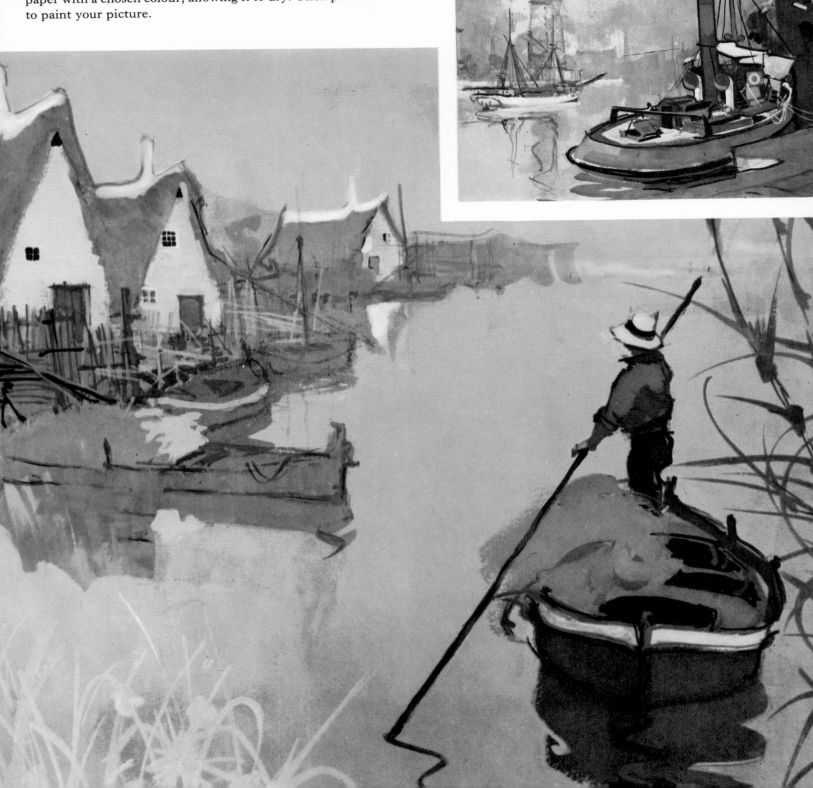

OIL-PAINTING

When anyone mentions painting, oil-painting is implied since it is the traditional medium. Primitive man painted in oils insofar as he used animal fats to dilute his rudimentary colours. The technique of oil-painting has always been used by the great masters and for the great masterpieces in the history of art. It offers infinite possibilities, and the results obtained with oil-paint are rich in effects of chiaroscuro, quality and colour.

Characteristics of oil-paint

Oil-paint is a soft sticky substance which, without requiring us to rely on spontaneity or chance, enables us to reproduce all the gradations of the sky, reflections and other effects in nature. Nor does it dry as you work, so there is always time to correct each colour, gradate every shadow and complete every detail at any juncture.

Oil-colours mix easily and the tones resulting are pure and brilliant. Oil-paint is absolutely opaque, i.e. the final application of colour always covers the layer beneath without spoiling it or losing its own colour. However, if you wish, rather than covering over, you can do some mixing in with the brush. The old masters sometimes covered parts of an underpainting with transparent glazes of various colours to give a glowing depth to shaded areas.

All these qualities make oil-painting a perfect medium, reliable and allowing corrections to be carried out.

* * *

Oil-painting is done on canvas stretched on a frame (a stretcher), but you can also use linen and even cardboard provided that they are treated with a waterproof solution, generally with a size basis.

The colours can be squeezed directly out of the tubes. They can also be diluted with turpentine and even if you do not use this for painting you must use it for washing your brushes. Wipe them with a rag after each application of a different colour. You should have several brushes at hand if you do not want to waste time washing them. In this way you keep one brush for a single or related colour. Once the work is finished, you should wash your brushes with soap and water as well as the turps to make sure they are completely clean. Otherwise the colour dries and they become as hard as wood.

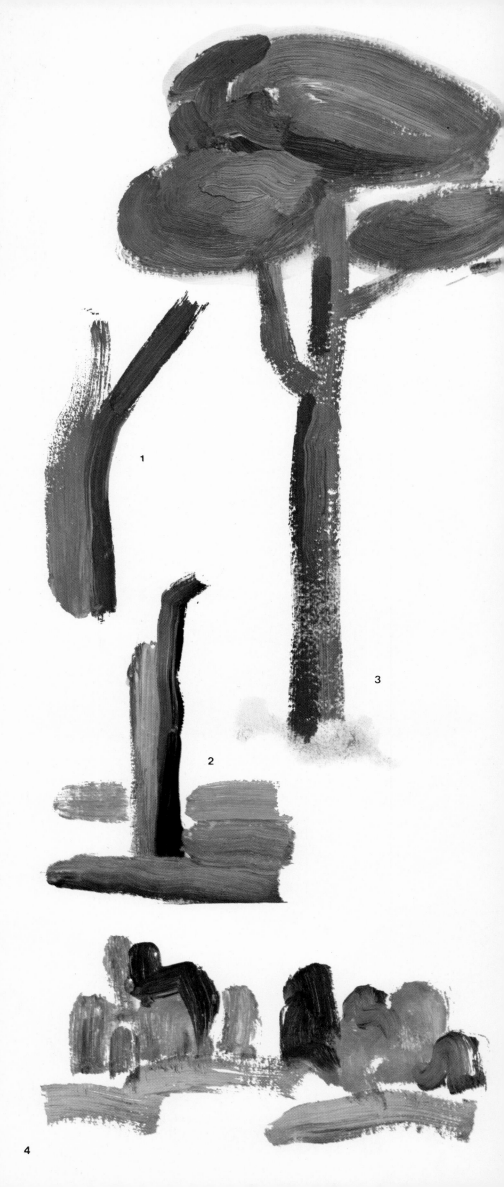

Some experiments

This is not a complete course in oil-painting. The technique is far too complicated for us to do more than explain the basic elements. You can now explore this new mode of expression with the possibility of developing the activity in the future if it gives you interest and pleasure.

Look at the examples on these pages. They are merely casual brush strokes. Note, however, how the colour itself is gradated, how effortlessly rich and how sweeps of colour, haphazardly put down, immediately take on some significance.

1, 2. *A few brush strokes and you have a tree trunk. A touch of a certain colour and it seems lit up by the sunset.*

3. *Provided you keep an eye on the changes of colour produced by the light on the green foliage, a whole tree materializes.*

4. *Green and blue for the grass, yellow ochre for the path. Pure oil-colour produces the effect.*

5. *Such is the luminosity of oil-paint that a patch of blue can become the sea; of red, a roof; of yellow, a wall; a green brush stroke, grass.*

6. *Earth, houses, sea, sunset and sky can be evoked by a few strips of colour. It is their combination that enriches them.*

7. *With these items you can begin to build up the basis of a scene: clouds, sea, village of white cottages, blue and red roofs, grass, earth . . .*

These examples do not claim to be compositions; they are merely try-outs with the brush. Do not look for their meaning but the beauty of the material, the particular characteristics of the brush strokes.

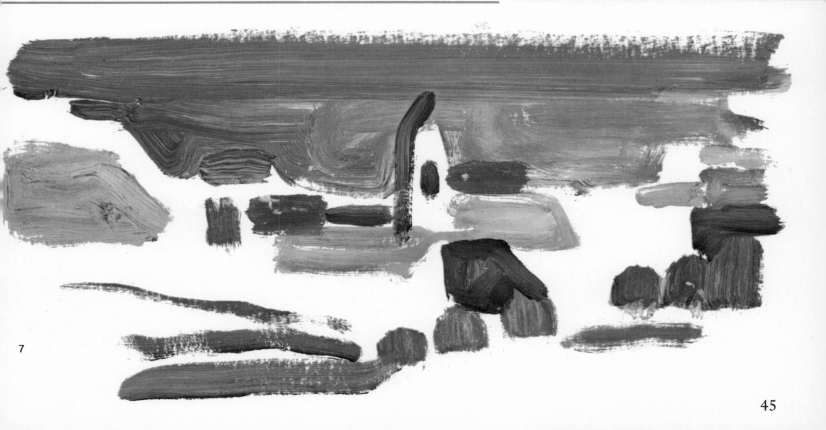

7

In these pages we will try and produce something more with our experiments. Let us set down the bases of an oil landscape, but within the simplest technical limits.

We see on the right a first experiment. Note the direction of the brush strokes and the impression of light which they produce. The blue sea contrasts with the light-toned houses.

The second example has the beginnings of a small picture, if not in any detail at least in the study of the colours with much stronger lighting than in the previous example. Look at the green brush strokes on the sea, the warm tones of the houses which seem drenched in sunlight and the attractive tones of the cloud-filled sky. You will get a better impression if you hold the picture a little distance away.

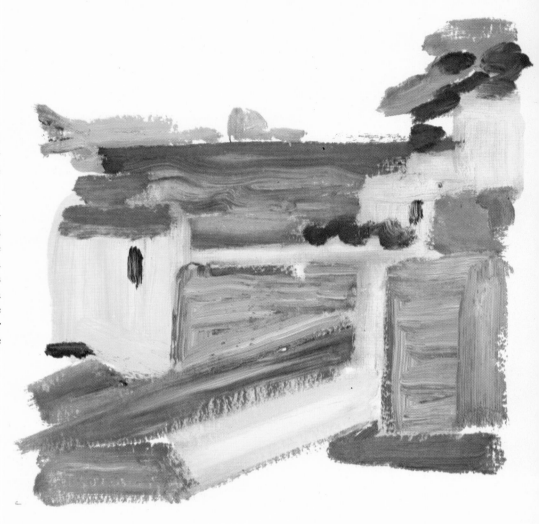

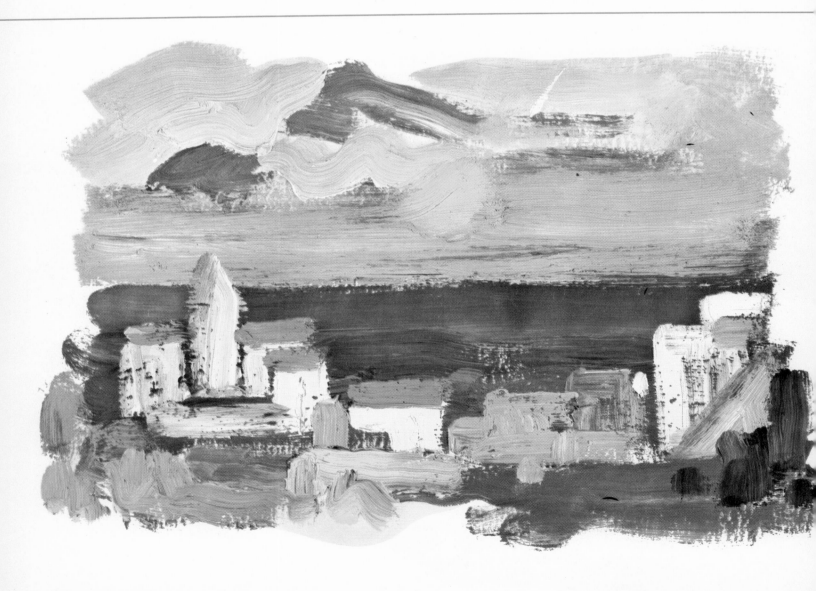

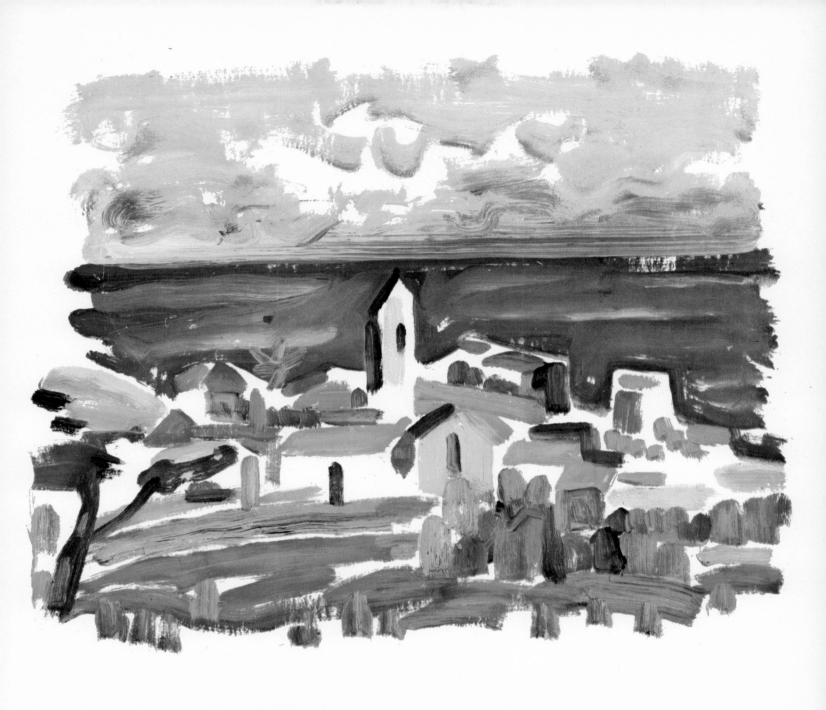

And, talking of impression, let us pass on to the final experiment: the whole village. For this subject a more impressionistic technique, using more primary colours and less realistic sfumatura, has been employed and the result is brighter.

The main thing is to feel the scene you want to represent and not to worry too much about unimportant details. A landscape and especially one in oils constitutes a whole, a single subject, one idea. It is not an assembly of small separate subjects. This does not mean that you should not take your subjects through to completion, but the main thing is the overall impression of what you are anxious to convey.

Exotic countries

A fascinating journey

So far we have kept to a familiar setting: man, the town, the country and the sea . . . The panorama however would not be complete without a long leap towards other horizons that offer new subjects and suggest new techniques.

Gauguin made this discovery and at the age of fifty felt impelled to leave France and settle in the South Sea Islands. There he found his real inspiration, became one of the best painters associated with Impressionism and produced his great masterpieces.

Not that we need to imitate his example nowadays. We can see these islands on the TV screen, in illustrated magazines and on picture postcards. You have therefore your inspiration in your own home.

Our imaginary journey will have three main objectives: exotic countries, the races of man and species of animals. Nothing less than the subjects which embrace the whole world of adventure.

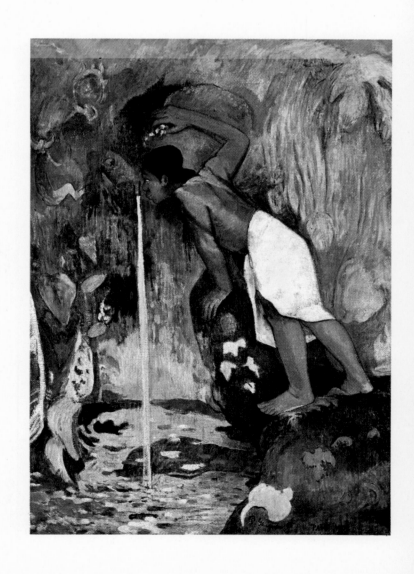

PALETTE-KNIFE TECHNIQUES

EXOTIC LANDS

For an exotic subject there is only one exotic technique—the palette-knife. It is the tool best suited to treating the entangled vegetation of tropical forests, the vibrations of hundreds of colours, the originality of nature in the wild.

The technique is a daring one. It requires syntheses of the forms and colours. Unlike the brush, it does not lend itself to making precise contours nor producing light and shade and merging tonalities as they appear in nature.

The colour is applied in dabs, almost constructing the subject in a series of small planes. The palette-knife technique obliges us to work with very tacky colour just as it emerges from the tube. The irregularity in the application and the density of the colour give the result an incredible forcefulness. For this reason this technique is much used by modern artists who are aiming at a richness of substance and are less concerned with form.

The palette-knife can also be used for tempera (gouache) and for all tacky pigments. Note the example (right) of a forest scene executed in this technique.

There are many types of palette-knife. The most practical is the one employed for the examples on this page, since it is capable of long and broad strokes and the blob, suitable for any subject.

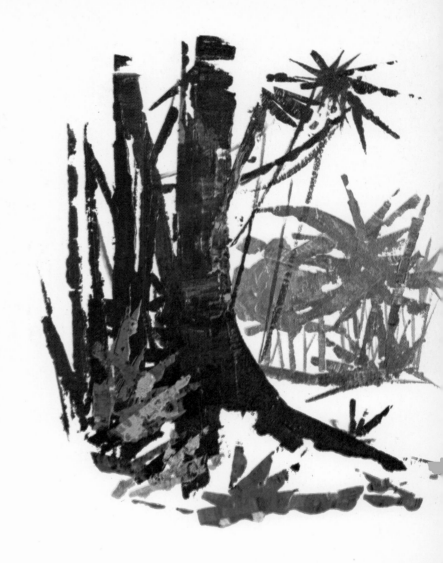

a

b

c

d

It can be used in many ways but the following four can be said to summarize them:
a) *Using the tip only, for making slight touches.*
b) *Applying the colour flat by means of pressure. These applications will take the shape of the palette-knife.*
c) *Horizontal use for spreading a large area of colour.*
d) *Use for removal of paint, leaving just a suggestion of colour revealing the white of the support or of the colour underneath.*

Of course these are only the main uses. You will discover others for yourself. Fundamentally it is the direct application of paint without the help of the brush, though the use of the brush is not banned. In fact a mixed technique can be most effective.

The special effect produced by colour applied with the palette-knife can be seen in the four simple examples on the right, made solely to show you what surfaces treated with this tool look like. You will note the odd effect produced by the colour reliefs and the particular nature of the strokes which make simple examples look almost like studied abstract paintings.

This textured effect should be exploited in your pictures, especially to cover large areas of rather monotonous colour. When executed with the palette-knife, a background even of a single colour can be rich and interesting.

The theme can be very simple, thanks to the transparency which the colours possess in varying degrees. The four experiments on the right-hand page show you the effects you can obtain. As you see, the subjects could hardly be simpler. What is remarkable however, is their plastic effect compared with similar subjects painted in the normal brush technique.

The first is a simple experiment in two colours with no further complication than the application of paint.

The second, slightly more complex, needs more care. The passage from brown to white requires the making and application of intermediate tones.

The third example is very similar to the second, except that the gradation is circular, the most luminous point being the centre.

The fourth is already a small imaginative picture in which various colours are called into use. The palette-knife offers the advantage of allowing the mixture of any colours, even those giving the maximum contrast.

An example of the variety which the palette-knife confers on large areas of colour can be seen in the buffalo subject below. Note the economy of colour and how the prairie where the herd is grazing has been executed in a single, dominant colour. The attractiveness of the whole is derived from the palette-knife treatment which gives texture to the surface, and so takes away the monotony which might have resulted if a similar treatment in other techniques had been used.

A picture in gouache by Francisco Miñarro

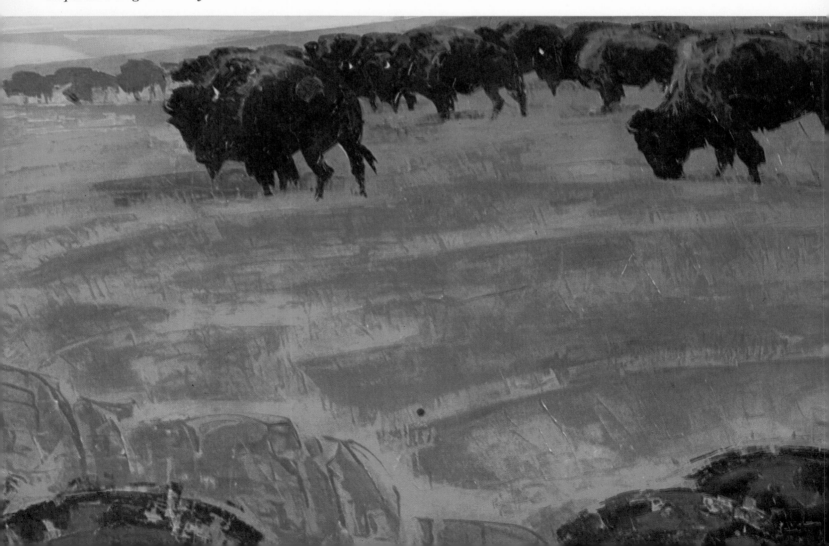

THE RACES OF MANKIND

 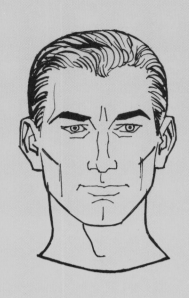 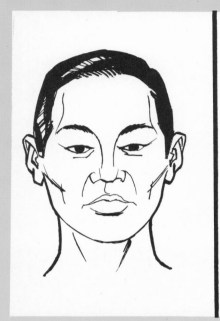 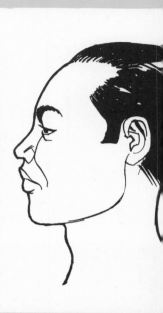

As you know, the world is populated with people of various races. These are many since, generally speaking, the inhabitants of each country have their own characteristic features, and furthermore one nation may include various racial characteristics. Think, for example, of all the differences amongst the people in Britain. These differences that stem partly from historical backgrounds have influenced habits, character and dialect as well as physical appearance.

Since it is impossible in two pages to catalogue all existing races—which in any case would be to go beyond our present purposes—we will deal with the principal races. A pictorial knowledge of these may prove useful to you, especially in the field of book illustration, since there are so many stories, of adventure in particular, in which Negroes of the forests, Indians of the prairies and inscrutable Chinese make their appearance. We are therfore confining ourselves to these three basic races from which, in the distant past, others were derived and which show the most marked divergences from the white races.

Mixed races may be depicted more vividly with the aid of costume and colour—aids not to be despised for identification purposes. Common sense will supply the rest.

Let us take an example: if you want to draw a Mexican, it would not occur to you to represent him as a blond with blue eyes, although we do not claim that there are no fair Mexicans. Doubtless you would depict them with thick lips, black eyes and dark-skinned. A black, drooping moustache and a sombrero will complete the picture.

Let us then analyse the appearance of the inhabitants from the remote world contained in our books and favourite strip-cartoons. In the strip-illustration above you see the yellow-, black- and red-skinned races contrasted with white. The differences shown are merely physical stereotypes for careful study. Each race, as depicted, has identifiable features, the mastery of which will help to make your illustration realistic. Let us quickly summarize the most striking of these:

We make no comment on the white race which we have already studied.

The yellow race is characterized by smooth black hair, almond-shaped eyes, the lack of creases on the eyelids, broad flat nose, wide turned-down mouth and prominent cheekbones.

The black race is mostly characterized by tight curls, receding forehead, flat nose, large prominent eyes that have a tinge of yellow.

Red Indians have a narrow forehead, an aquiline nose, deep-set eyes. Their features are sharp; their large mouth has thin lips. Their prominent chin gives them a dignified and confident appearance.

When you have learned to draw these features, you can deal with characteristic costume in order to complete the picture.

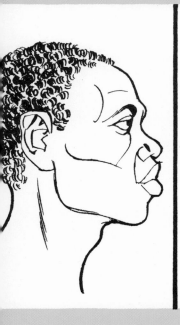
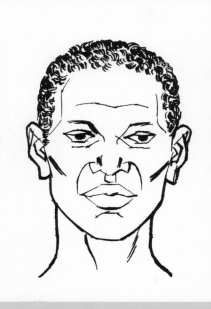
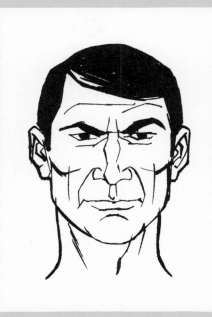
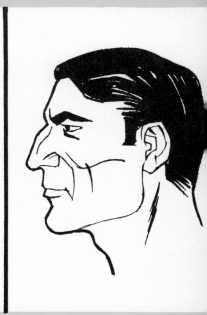

Since you are using brush and Indian ink (that is no half-tones) for these costume illustrations, you must bring out the contrasts very clearly. This technique is generally adopted in strip-cartoons because of its simplicity. To avoid the problems arising from the lack of precision of the brush compared with the pen, you should work in large shapes which can be scaled down by the printer.

THE ART OF EXOTIC LANDS

Each civilization has its own artistic tradition. It can be said with some truth: the more exotic the country, the more exotic (compared with the west) its art, since art is merely a reflection of environment. The most exotic art—and as such the most interesting—is that which has evolved unaffected by other countries, either because of its isolation or because of its own tradition.

The latter is true of Egyptian and Greek art, neither of which, as far as their particular civilization and tradition are concerned, resembles any other art.

Other countries, however, owe their particular artistic idiom to their development in isolation from other civilizations. This applies to Oriental art, especially Japanese. Because of this solitary evolution, their artistic and graphic techniques differ widely from European. Other even more isolated countries, discovered (for the Spanish crown) by Christopher Columbus in 1492, are the Americas where aesthetic aspects are also individual. The African forests, too, have been responsible for the isolation of races which, in various stages of civilization, have had their own genuine form of expression.

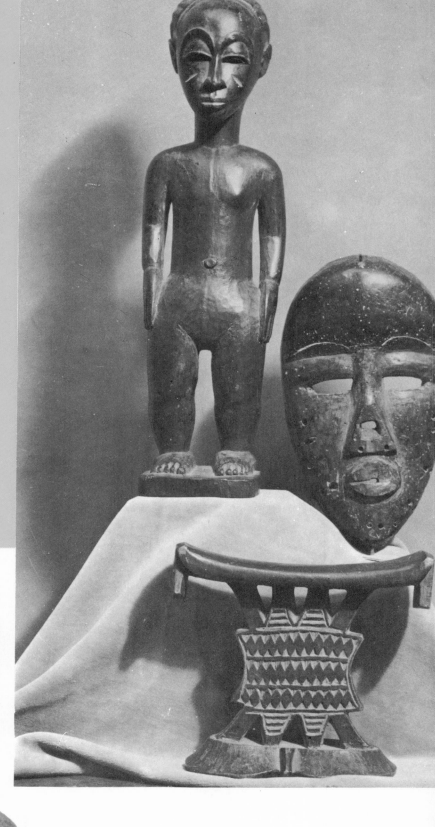

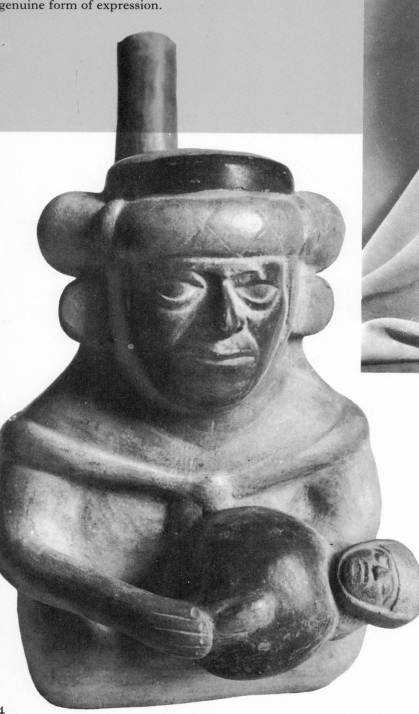

Three examples of African art. The top one is a Baule fetish (Ivory Coast). Below it is a Dan mask (also Ivory Coast) and the third is a Nakalanga cushion (Rhodesia).

Very ingenuous but certainly beautiful is this Protocimi ceramic; it is an expression of pre-Columbian culture.

Black lacquer fan which, in spite of appearances, is not Japanese. The artist was obviously inspired by Oriental art and realized how to imitate its delicacy.

In various countries throughout the centuries art has developed on parallel lines. Each civilization has succeeded in extracting the maximum from its individual way of expressing beauty.

It is now perhaps the moment to exchange our knowledge and experiences, study these exotic cultures and assimilate some of their lessons. The Impressionists owed a great deal to Japanese art.

Let us try and create an example of 'exotic' art, in the form of a clay mask, taking our inspiration from the arts of tribal Africa. Since you will find the whole human figure difficult, it is a good idea to practise with this type of subject. The exaggerations involved will free you from technical problems and the result will be both interesting and decorative.

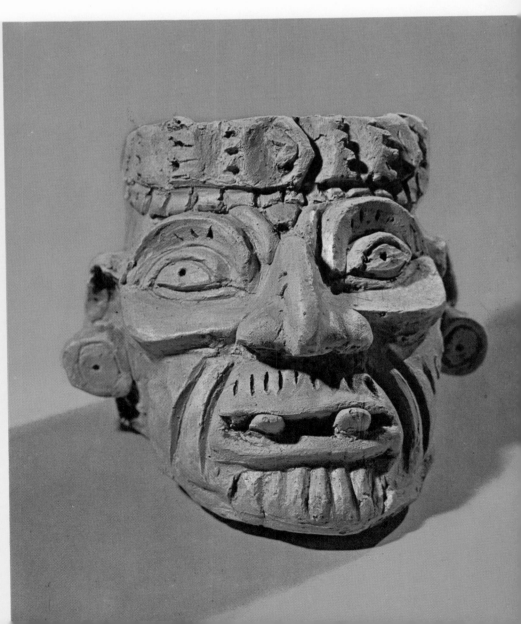

ANIMALS

One can hardly discuss distant lands without pausing to consider a universally favourite subject among art students. Thousands of lions, tigers, horses, bears, tortoises, elephants appear every day in students' sketch-books. You yourself must have drawn scores of animals since first picking up a pencil. In sculpture animal subjects are a must.

This is logical enough since no subject offers more variety than the animal kingdom. It embraces the short and the tall, the round and the flat, the hairy and the bald . . . One can hardly draw a few random lines without suggesting some animals. Furthermore, since they are alive, they provide wonderful subjects rich in meaning, form and movement.

You all have a certain idea of what the most well-known animals look like but you must get to know them properly before you can draw them satisfactorily. The simplification of the original forms while preserving their basic characteristics will come at a later stage.

Visit the nearest zoo, armed with a charcoal pencil and a sketchbook. Those who have no access to a zoo should do the best they can with illustrations in magazines or the animals they see on the TV screen. But whenever possible it is essential to observe animal forms from life since the need for them occurs so often in any graphic work you undertake.

Drawing from life

Look at these charcoal studies made during a visit to the zoo. It is immediately obvious that they are drawn from life. This feeling has nothing to do with the finish of the drawings, which is of minor importance, but from the accurate representation of the harmony of movement and anatomical grace. When you get back home you can finish from memory the sketch which seems best.

With the time and means available you can make–from life–attractive colour sketches such as these of the parrots in body-colour on the page facing. Practise this type of study as much as possible. It is most rewarding.

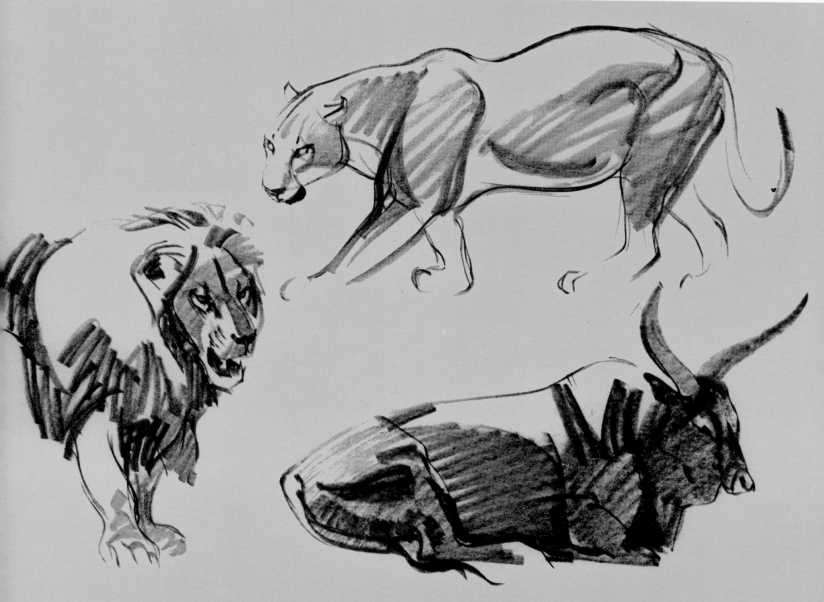

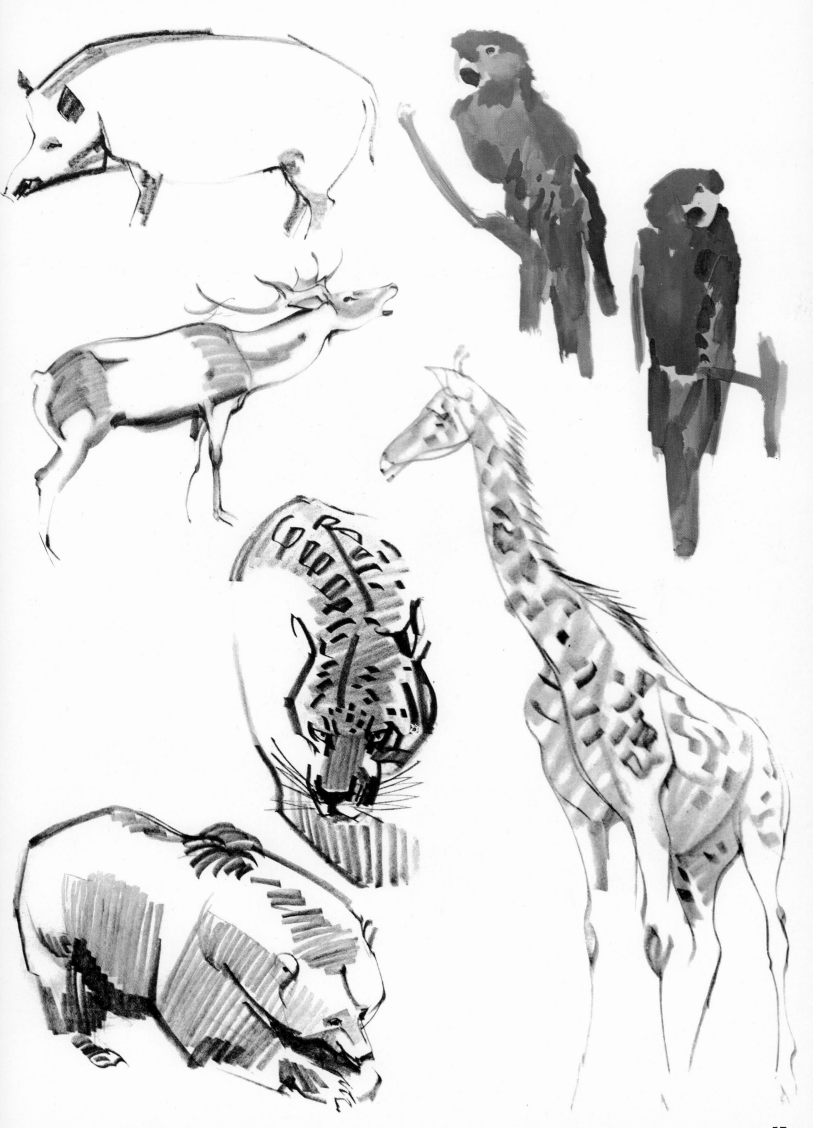

PASTEL TECHNIQUES

Do not confuse pastels with coloured pencils or wax chalks. Pastels are very soft sticks. These old friends of yours offer a very expressive medium, rich in artistic qualities. It has, however, one drawback: unless you 'fix' the drawings the colours fade and smudge. Their value lies in their subtle and attractive colours.

Look at the two examples on this page. They are unpretentious colour studies executed on the spot. Observe how, despite the extreme simplicity of treatment these few touches of pastel add the richness and strength which this type of subject calls for. Animals are always handsome provided you give them this true-to-life quality and spontaneity which only an on-the-spot sketch can supply.

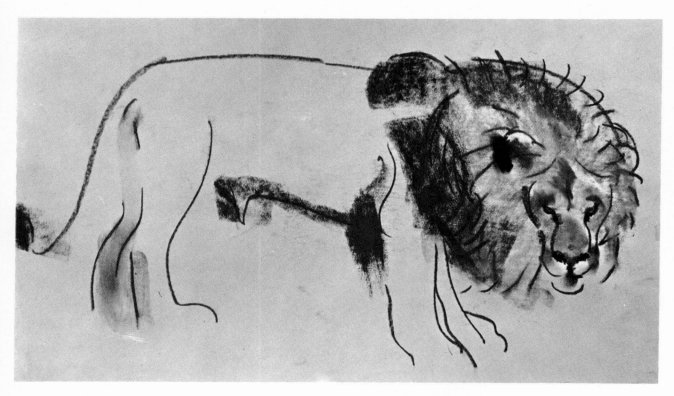

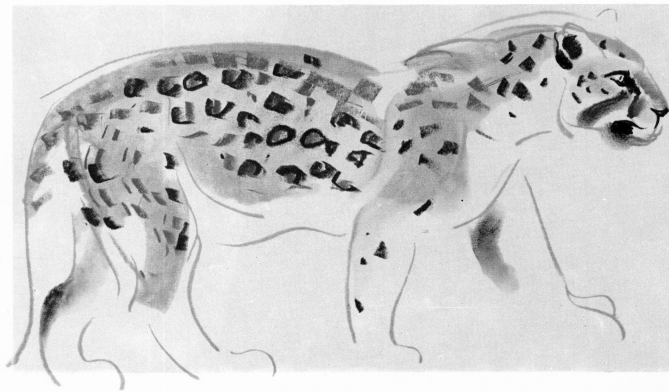

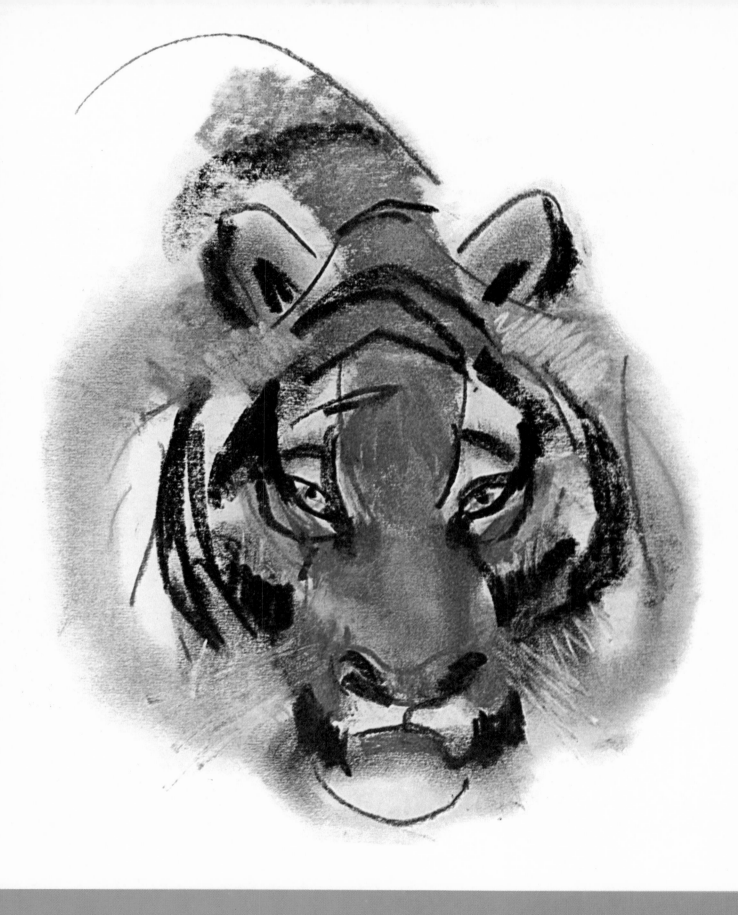

The felines

Of the best-known wild animals, the feline species present the greatest variety within a family resemblance. In fact one needs to be a considerable expert on the details of each variety to note the anatomical differences between a lion, tiger, leopard, panther etc. It is true that tigers have black stripes on their coats, lions (male) a mane and so on, but there are less marked differences. On these pages you observe three types of feline. Study their differences carefully. After that, practice and observation will enable you to exploit the results.

The tiger's brilliant colour and fierce expression make it the most handsome of the felines. It would be difficult to bring out these qualities so successfully in any other medium.

ANIMAL DRAWINGS

We now suggest an interesting experiment on the theme of animals. The idea—as you see from the facing page—is to produce drawings of various animals, birds etc. to fit into a series of frames of identical dimensions. This offers a discipline and a challenge. You will have no difficulty in thinking of uses for the results; for instance they would make attractive invitation or greetings cards etc.

Preparing the cards

To keep the heights constant, use the set-square as shown in the diagram. Once the horizontals are drawn, apply the vertical measure, always with the aid of set-squares. Cut the horizontals first in strips, then do the vertical cuts on the lines you have drawn.

Decide on the animals you propose to draw and, depending on the particular purpose you have in mind, do the necessary research with the aid of

books, magazines, encyclopedias etc. It can be an individual or a group theme—or just a game.

On the facing page, you can see the dimensions and characteristics of some of the drawings. In them you will find some animals 'explained', as it were, to facilitate your task. However, do not make direct copies. Follow out your own ideas especially with regard to technique and colour—absent in the drawings reproduced so as to give you a free hand in your choices.

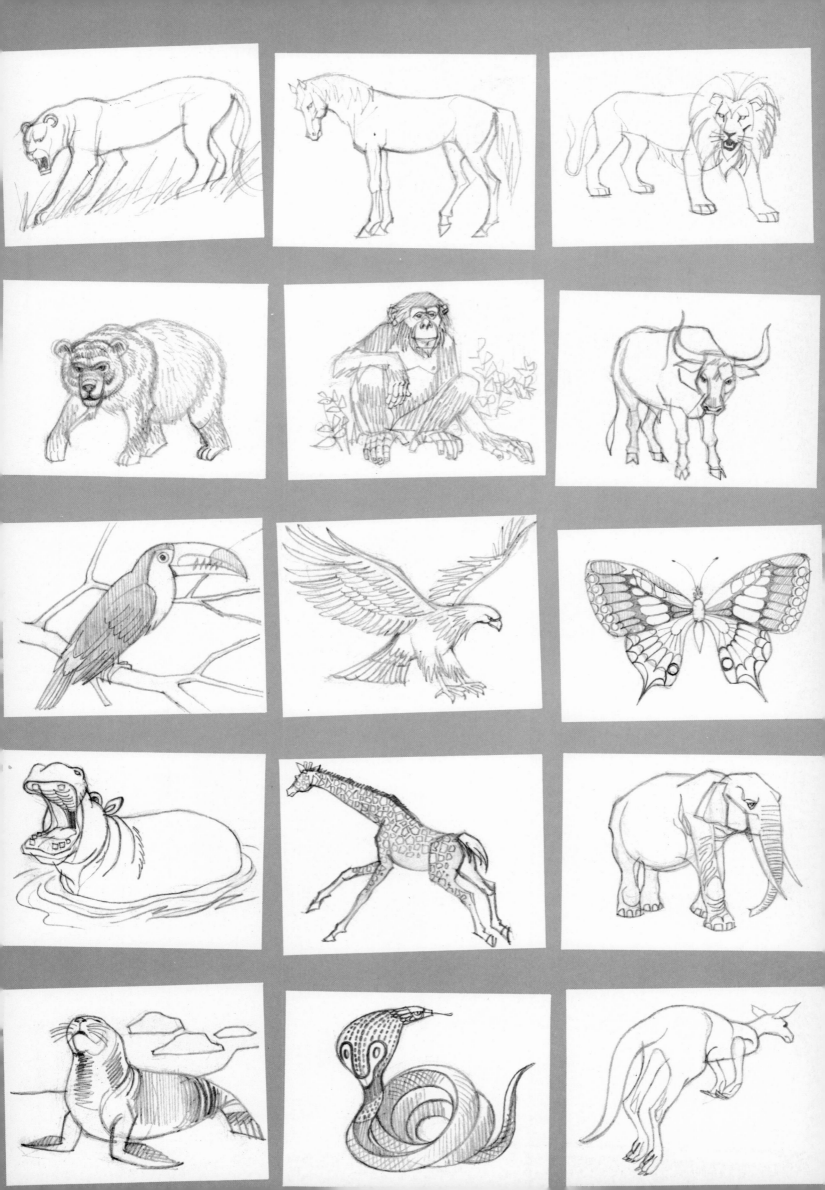

Synthesis of animal forms

A final lesson on animals: the process of summarizing (making a synthesis) is indispensable to any genuine artistic representation. In the preceding lessons you have already studied the real forms of better-known animals. Now, by a process of elimination, you can arrive at a more expressive simplicity.

We must insist on the importance of this process of synthesis. It is the key to beauty and the mark of the true artist since it stimulates the imagination and results in a personal version of the subject selected, so necessary for artistic creation. In the realistic representation, since the personal interpretation is less evident, the eye contributes more than the imagination. When you express yourself freely, the results become more varied and interesting. But before reaching this stage, you must familiarize yourself with real forms so that the beauty created shall be the product of analysis and not chance or improvisation.

How to arrive at syntheses

The way to achieve a successful stylization of a subject involves two qualities:

– Knowing how to 'see'
– Knowing how to express oneself.

It is not difficult to learn how to 'see'. It consists merely in selecting the most representative and indispensable features of the subject—those which define the form and give it its character—and then eliminating the subsidiary details.

As far as expression is concerned (or rather the execution) you need to exploit simple, even geometric forms—learning to choose those nearest to the real forms and omitting useless details.

Look at this picture of the tortoise, reduced

to its simplest, essential terms. We arrive at this synthesis not by accident but after an accurate study of the actual form of the animal. Note, for example, the positioning of the feet and you will agree that they could not be more convincingly placed. This simple reduction to curved forms is amazing: one large semi-circle and two small ones, one of them divided in two. As you see, it is very different from an improvisation.

The same principle is applied to the execution of the bird below, which you see represented realistically—drawn from life—and then in a stylized version, executed in a highly decorative and certainly original way. The distance that separates this last example from reality conveys some idea of the great possibilities of this method of synthesis.

Pupils' exercises,
Massana School, Barcelona

On this page are two highly individual versions of a snail, two ways of interpreting the same object. The first, without being realistic, keeps fairly close to the original form which is now elegantly stylized. Wood, the material used, adds a richness of texture to the result.

The second version, carved in plaster of Paris, is a free interpretation, in fact it takes the process of synthesis to the ultimate extreme. The result combines great originality with beauty and shows considerable powers of observation. The exploitation of the spiral, symbolizing the shell, is particularly effective, especially as it offers no special problems of realization. The harmonious effect of the whole is enriched by the erect position of the front part of the snail, and on the top of this a gentle hollow hints at the horns.

A similar spirit of synthesis together with the same material were employed for this elegant crocodile whose expressiveness is in the form of its head and its tail. The feet could hardly be more simply suggested. The same applies to the tiny scales on the reptile's back which recall the actual texture of crocodile skin.

Communications

Communications, a matter of perspective

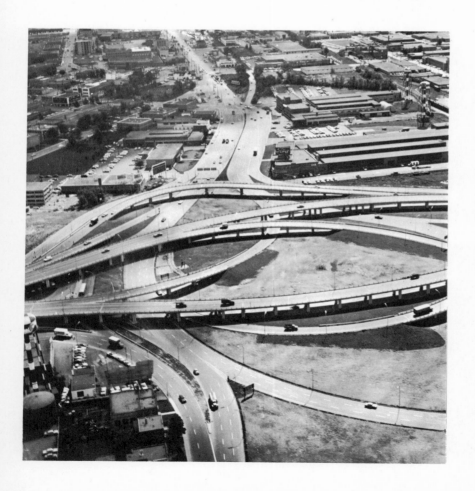

The modern pattern of motorways, bridges, railway tracks etc. is born on the civil engineers' drawing-boards, following an accurate planning on the part of expert technical draughtsmen. Naturally when they pass from the plans to reality and the job itself on the site, this geometrical perfection is transposed on to the landscape. The asymmetry of the tree or the boulder planted here or there by nature is replaced by the symmetry and linear pattern which characterize the work of man.

To represent this subject adequately, however, we must enlist the aid of perspective, the correct application of which will give verisimilitude and technical perfection to our drawings. The surveyor uses set-squares and ruler to carry out his projects, and we must adopt them too for transferring these spectacular landscapes on to paper.

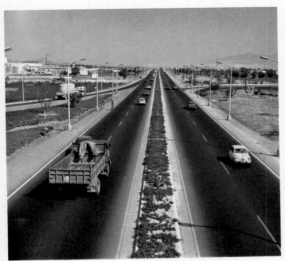

Here is a subject which requires some knowledge of perspective for its execution. This exercise looks elementary, but it demands a mechanical exactness for a correct interpretation. Perspective studies of this kind, which need to be very accurate and involve various elements, are difficult to improvise because of the different planes on which the elements are situated. You can test this by attempting such a drawing without the help of perspective. After completion, take your ruler, draw the horizon line and vanishing points and check the result. In the nearest items, there may be a slight error, but you are sure to find considerable disproportions and inaccuracies in the distance.

This time, then, let us try to obtain an accurate, linear representation of the dual carriageway shown on the left.

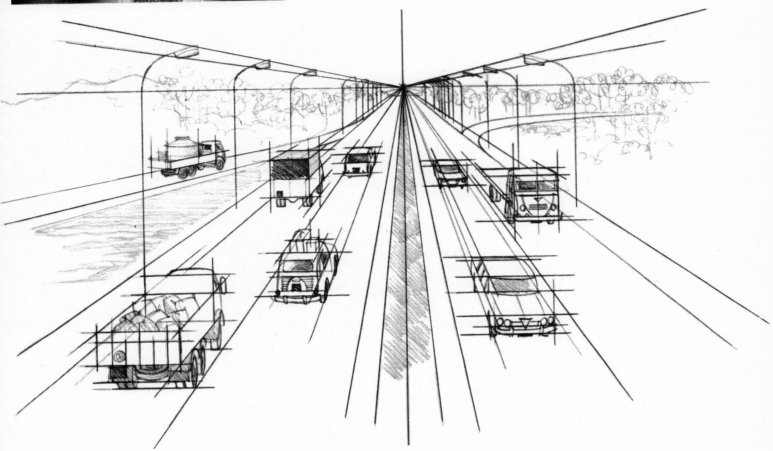

The perspective here is of the most elementary kind, i.e. from the front with a single vanishing point. So, once the proportions are lightly sketched in, you must determine the horizon and single VP from which all the main lines will radiate—those of the traffic lanes, and those of reservation areas and verges.

We must also place the lamp standards whose height will be conditioned by the perspective line which we draw from the foreground lamp to the VP. Also take into account the fact that the distance influences not only the height of the standards but the distances dividing them, progressively less as they recede. (Note how the farthest standards appear almost joined together. Remember that at this distance a millimetre's separation corresponds to several metres in the foreground.)

It now only remains to fit in the vehicles on the road and decide what particular types we want to depict. Once these are sketched, we can proceed to the final version in accordance with the VP up to which all the perspective lines of the vehicles must lead. The sole exceptions will be the vehicles or other items outside the main perspective framework, e.g. the petrol tanker advancing along the secondary road.

It does not matter if the whole effect seems rather cold; after all, this is an exercise in perspective. If you decide to finish this drawing, add colour. The effect will be to soften the whole by such free-hand touches. It is of no consequence if the result is slightly less geometric. As long as your work is built on a sound basis of perspective, it will seem properly constructed and—important for this kind of work—will create the illusion of reality.

Here is another example of perspective with a single VP. The technique adopted for the dual carriageway subject holds good for the depiction of this modern train. Bear in mind that all the guide-lines converge on the same horizon line; track, coaches, windows etc. The one thing to watch out for is the relative lengths of the coaches according to their distance from the picture-plane. As with the lamp standards, the further away the coaches, the more foreshortened they will appear.

We cannot however always manage it so easily. When the train (or the road or the street etc.) is not straight, we have fresh problems. Look at the second example with the old steam-engine. Here the track describes a semi-circle and the locomotive as well as the coaches have different positions in relation to the horizon line. How do we cope with perspective in this case? Simple enough, by finding a VP which varies for each coach, ending, of course, on the same horizon line.

Being a complex subject, perspective has many laws. Its aim is to produce the illusion of reality. However, without going too deeply into reasons, there is one very practical hint. Look at the drawing of the ships. Note that

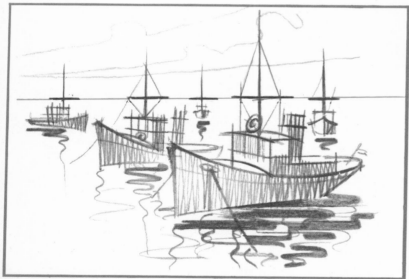

all the boats have their cross-trees on the horizon line. So if we want to draw other similar boats, we should place their cross-trees similarly, no matter how far away they are.

The second example (the steamships) illustrates the same principle. In this case the horizon passes along the decks of the various ships. Whatever other ship we add should have its deck similarly on the horizon.

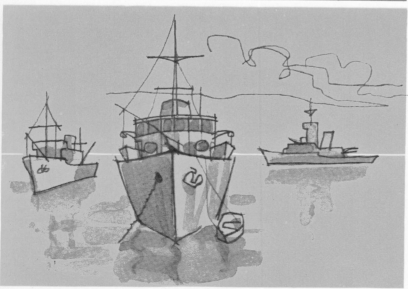

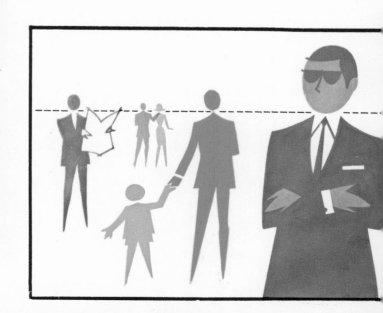

The last example on the preceding page shows how the rule applies equally to human figures. In fact if one figure has its head above the line of the horizon, all the figures (except those of the children) have their heads similarly above the line. This rule will help you to avoid major errors in the placing of figures seen in perspective.

Before concluding this chapter on communications and how to represent them, let us look at a final example which introduces a new factor: curves.

This is the right moment to mention an additional geometric instrument known as 'French curves'. This instrument is no use for ordinary drawing but it is a practical aid for finishing certain curves which have to be drawn in correct perspective. Once their form is determined, you can make use of the French curves instrument to find those that correspond to those you need. With the help of compasses this can provide you with an accurate finish to all your curves without your hand playing you false.

However, this resource is more suitable for the

execution of technical or precision drawings. From the artistic point of view, it is best to use it sparingly.

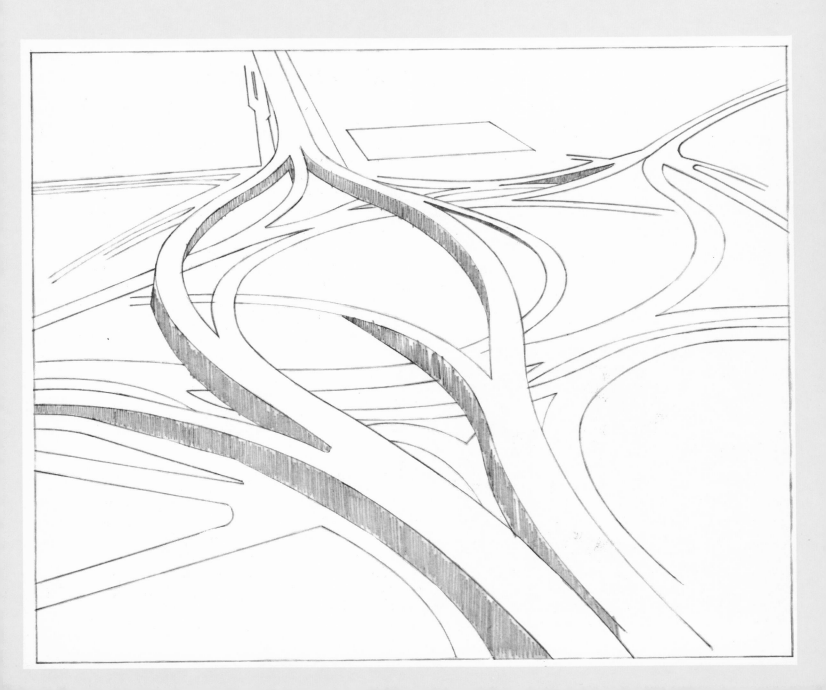

Space

Light and shadow

Our eyes distinguish shapes and colours because light reflecting from them enables us to identify them. Shadows, as opposed to light, allow us to distinguish objects, understand their forms, realize what substance they are made of and also their position in relation to other objects.

In order to illustrate this property of shadows—or of light, if you prefer it—we have made this diagram of space in which the only factor that enables you to identify the exact position of one planet, relative to the others, is the light it receives. According to the direction of light each one appears nearer or more remote whatever its relative size. This introduces another lesson.

The perspective of shadows

Up to now whenever we mentioned perspective, we were referring to physical objects: houses, roads, cars . . . but there is another type of perspective, and it concerns shadows. This branch of perspective is certainly more important than linear perspective since its effects tend not only towards precision but also artistic expression.

When we speak of the perspective of shadows, we need to make a basic differentiation between:

- Those produced by daylight
- Those produced by artificial light.

In the two insets on the right you will observe the difference: whereas the rays of natural light are parallel, those of artificial light are radial, or converge into the source of light.

The shadows made when the sun is directly overhead have the same dimensions as the object which produces them, whereas those derived from an artificial light will increase in proportion to the proximity of the object to the source of light.

Natural light

Artificial light

Here is an example of shadows produced by sunlight. The outline of the aeroplane is projected virtually undistorted except for a slight slant of the rays of light.

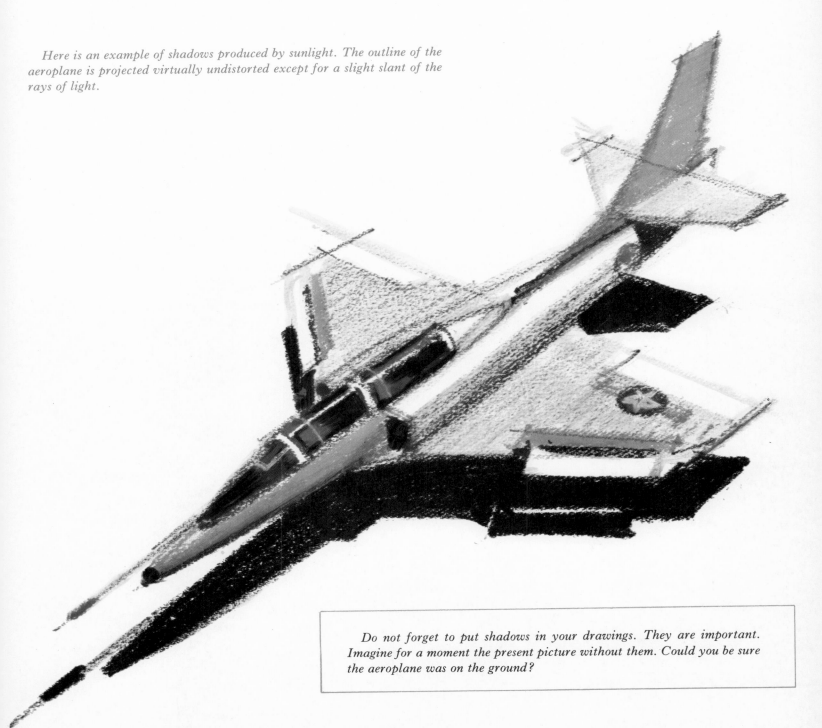

Do not forget to put shadows in your drawings. They are important. Imagine for a moment the present picture without them. Could you be sure the aeroplane was on the ground?

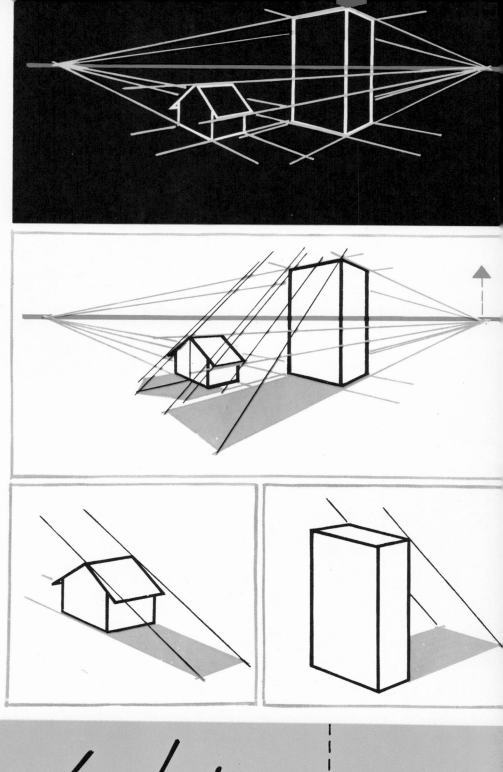

Now look at some practical examples of shadow perspective. The top inset shows you a perspective diagram. In order to project the shadows correctly you need to start from a perspective diagram of the subject.

In the second example you can see how the shadows are determined. The sun's rays (converging on an imaginary point in the sky) intersect the lines of the perspective (shown in the top illustration) after passing through the most projecting points of the subjects drawn.

The third and fourth diagrams show you how the perspective of the shadows may fall in any direction depending on the position we give to the sun.

But these examples are over-simple, since we have made the shadows coincide with the perspective lines of the buildings. This seldom occurs in reality because the direction of the source of light is one element, the arrangements of objects on a plane a separate consideration. The sole common element is the horizon line on which we will find the two VP's corresponding to the buildings and another point corresponding to the direction of the light under the sun's vertical position. To understand this more clearly, look at the large diagram in different colours, the perspective lines of the buildings and those derived from the rays of light. Note how, once you have decided on the sun's position, all the shadows fall into the same perspective framework.

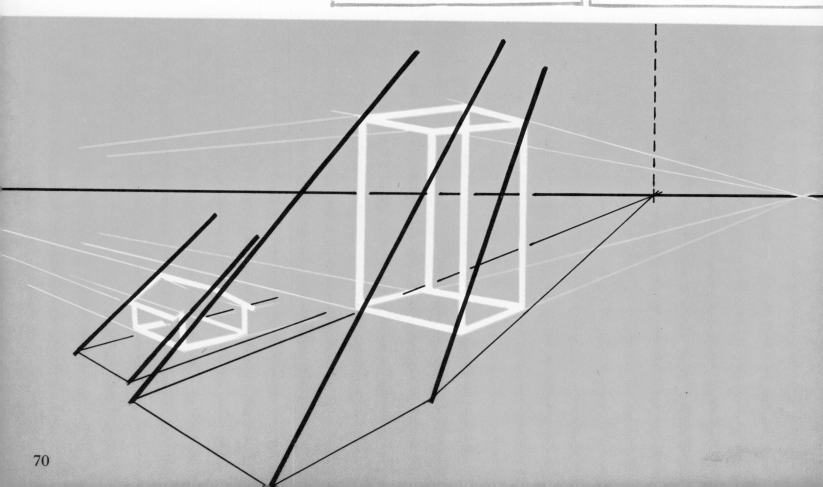

Artificial light

Note in this drawing the effect of artificial light on the subjects surrounding the lamp post.

The lines of perspective do not start from the horizon as in the case of natural light, but from a point situated on the ground under the vertical source of light. From it radiate all the perspective lines of the shadows whose length is determined by the rays of light, which, emerging from the source of light, intersect the perspective lines.

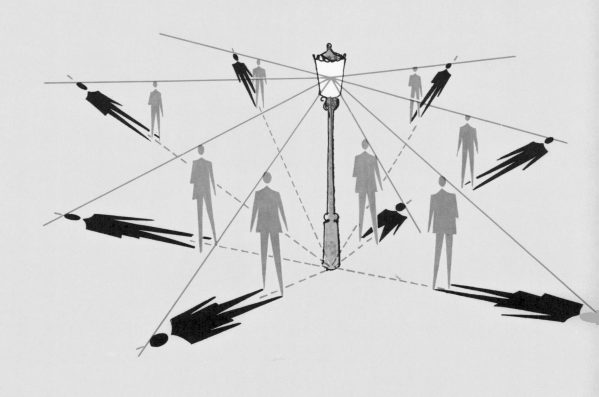

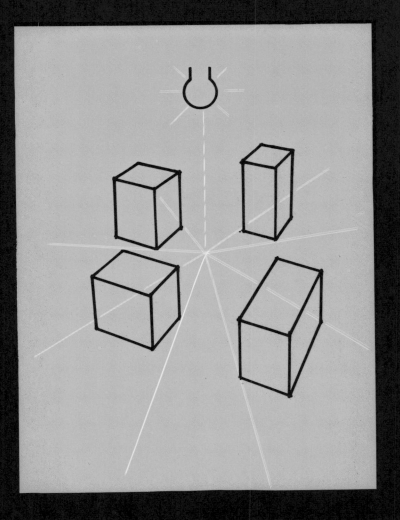

In the case of the lamppost, the point of perspective was easily identifiable, thanks to the fact that the vertical was provided by the post. Here we show how this problem is solved when the light is above: you only have to drop an imaginary perpendicular line from the source of light on to the ground.

And here is the final result. This example has turned out rather more complicated than the first because the position and the volume of the objects require more attention. One line wrong and the shadows will be falsified.

Now observe an illustration which presents two new aspects for you and which may prove useful.

The first is the representation of space. In fact this drawing has two widely separated subjects: the space ship and the moon. In order that this distance can be seen, the colours of the two subjects must be of different intensity. In fact the space ship is much more distinct both in form and colour. For the depiction of the moon, on the other hand, strong colours are avoided or at any rate black. This differentiation clearly places the space ship high above the moon.

The second lesson of this illustration is the way in which direct light has been applied. To do this, we started with a piece of coloured paper on which, once the main items were set down and the shadows drawn, all the illuminated areas were picked out in white pastel. This method has enabled us to gain an attractive effect, and the avoidance of black has had the result of strengthening the lunar shadows.

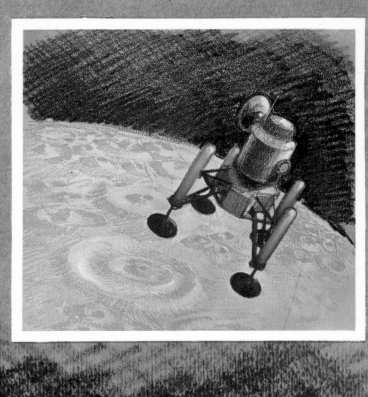

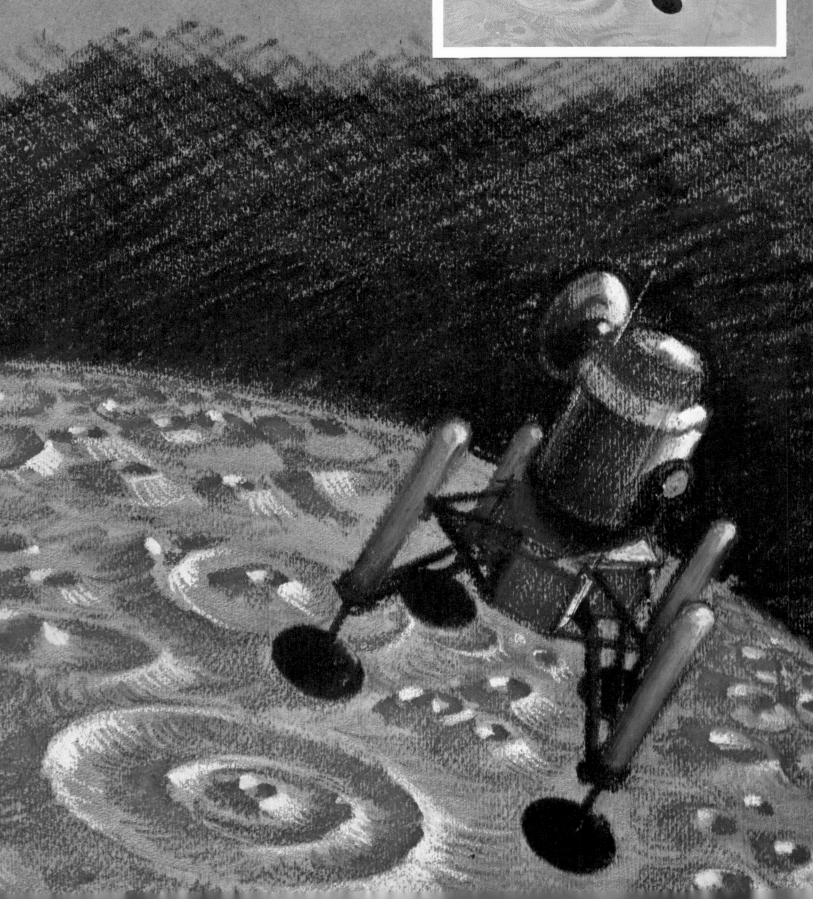

LIGHT AND SHADOW AS AN EXPRESSIVE MEANS

Some artists make the mistake of giving undue importance to the form of the subjects without taking into account the great expressive power of light and shadows. You should bear in mind that they form an essential part of the composition occupying a physical space in the picture exactly as if they were solid objects.

Look at the still-life below by Velázquez in which you will appreciate the importance of the shadows from the point of view of composition and representation. They place the objects precisely in relation to the wall.

Light and shadows furthermore may be fundamental elements for providing a setting for subjects. Almost all surrealist works exploit light and shadow to evoke strange effects of unreality. With this in mind, consider the Chirico painting on the right, *The Anxious Muses*, in which the perspective of the shadows plays an essential rôle in the setting.

'Reading' a work of art

What is art?

At the risk of over-simplification one could say that art is man-made beauty.

And the artist?

The artist is the man whose value lies in his ability to give visual expression to his thought and feelings about things.

What is a work of art?

It is the representation, through various techniques, of feelings, forms or colours intimately experienced and expressed with harmony, power and beauty.

And an artistic period?

It is the ensemble of human, social and environmental factors which condition the direction and form of works of art executed during a certain period.

'Reading' art then implies understanding what the artist wanted to express and knowing how to appreciate the beauty of his creation, at the same time being aware of the artistic period when the work of art was carried out. Reading works of art is not easy but we have various analytical aids at our disposal. These will help us to appreciate their beauty and in particular the various kinds of attraction or interest which each artistic creation contains.

A work of art may be beautiful by virtue of:
Form
Colour
Technique
Harmony of form or colour
Synthesis
Expressive sensibility
Feeling
Power of expression
Psychological content
Descriptive exactitude
Documentary or topographical value
Message or purpose
Fantasy
Originality
Dramatization
Composition
Choice of subject
Realism
Quality of substance or technique
Expressiveness
Action or movement
Chiaroscuro
Decorative richness
Ingenuousness or spontaneity of forms
Abstraction or symbolism
Unreality or exaggeration
Setting
Viewpoint or 'shot'
Functionalism, etc.

As you see there are countless approaches to a work of art, all interesting since their aim is the creation of beauty. It would be impossible within our limited space to explain the full potential of each of the aesthetic factors listed, which, apart from anything else, need a sense of proportion to determine when and in which works they should be used. However, let us try to analyse some examples so that when you see what the artists of various periods have achieved, you can understand the method they followed to attain the masterpiece in question:

1. *Calumny*
Sandro Botticelli
Uffizi Gallery, Florence
The Renaissance is one of the most complex styles in the history of art. The beauty of Botticelli's work lies precisely in his imaginative composition, made up of the movement of people within settings of grand appearance. The unreality of the whole and the technical perfection of its execution make this work an unambiguous example of Renaissance art.

2. *Red Balloon*
Paul Klee
Guggenheim Museum, New York
Klee was one of the first to discover the possibilities of the geometrical composition of colours. This work, like all his other works, is a masterpiece of colour symphony, of the accurate arrangement of the parts. The balloon, the only round element in the midst of a strange city made of windows and doors barely hinted at, is merely a pretext for playing with forms, colours and spaces in Klee's inimitable way.

3. *The Cab*
Carlo Carrà
Private collection, Milan
Our minds are full of images, but they are not photographic images full of details. We store away in our memory only the most characteristic objects that we see.

The attraction of this painting by Carrà lies in its absence of detail. The forms are exaggerated, almost childish; but they have the quality of being so expressive that the subject appears to us with that same simplicity as in our imagination. The technique and composition make this ingenuous work a truly aesthetic creation.

4. *Birth and Vocation of St. Nicolas* (polyptych of Perugia)
Fra Angelico
Pinacoteca Vaticana, Rome

1

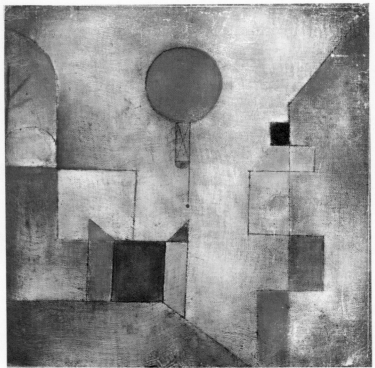

2

5

4

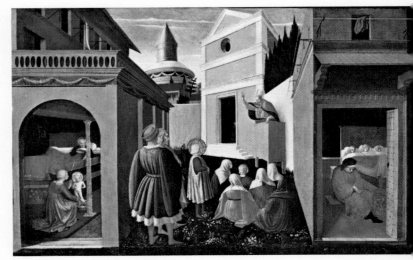

6

7

8

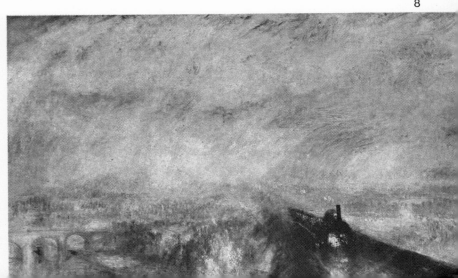

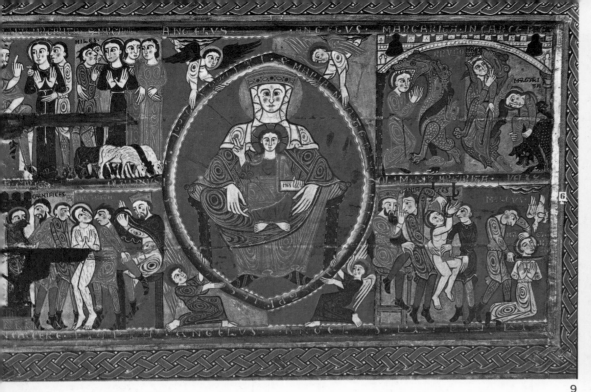

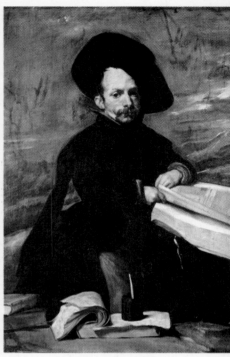

9

14
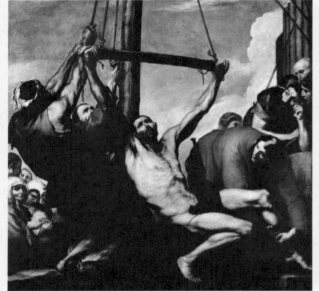

15

16

The characteristic of this work is the clarity of the exposition. Everything is governed by what is taking place in the picture. In fact, maybe because of the typical ingenuousness of the period, the aim of such works was to illustrate, express and describe. Its attraction consists in the primitive but accurately executed perspective and in the minute descriptiveness which makes the picture a genuine pictorial story.

5. *Ménerbes*
Nicolas de Staël
Private collection, Paris
This is a real oil-painting in which all the qualities of the medium and technique have been exploited. The colours are harmonious, applied 'impasto' with a palette-knife cleanly and with confidence, exploiting to the full the tactile beauty of the painting substance. The juxtapositions of colour

and the brightness of the oil-paint give de Staël's work a feeling of unusual freshness and skill.

6. *Bougie*
Albert Marquet
Gallery of Modern Art, Venice
The originality of this marine painting lies in its viewing point. Marquet has grasped the plastic potential of the foreground roofs. However, this picture would not be completely meaningful without the ship of which we catch a glimpse behind the warehouses, and without the two thin lines enclosing the harbour. These simple elements, aided by colour, give this marine painting a special flavour.

7. *The Seine at the 'Grande Jatte'*
Georges Seurat
Royal Museum of Art, Brussels

11

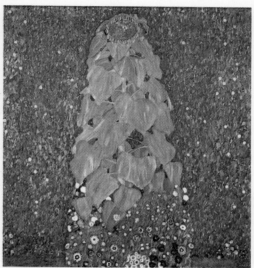

12

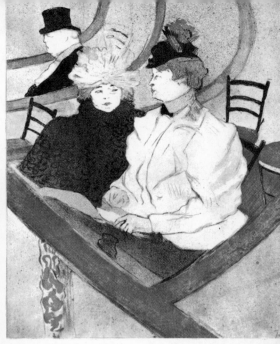

13

17

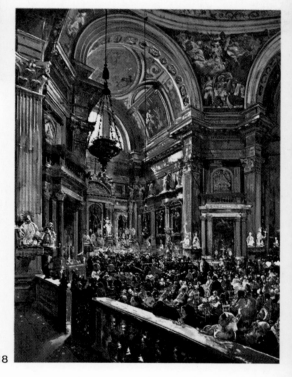

18

This work represents a particular style of the Impressionist period. Its attraction lies partly in its technical quality known as Pointillism or Divisionism. Here the vibration of the colours of nature is successfully produced, likewise the optical illusion of light in its composition of thousands of dots of paint. It was a new way of seeing colour.

8. *Rain, Steam and Speed*
J. M. W. Turner
National Gallery, London
In this title Turner conveys the full meaning of this painting. In a single subject he has represented three ideas: setting, subject, movement. Of the three, however, setting is the most important and the most successful.

It does not matter if the forms of the elements are only hinted at. Atmosphere predominates and

endows this original concept with a deep sense of reality.

9. *Madonna with Infant Christ and the Legend of St. Margaret*
Catalonian art
Episcopal Museum, Vich (Barcelona)
Medieval art possesses the magic quality of simplicity and clarity of expression. The forms are rudimentary not to say childish, the colours brilliant and simple, perspective is neglected. This unreality, this rigidity of forms shows a great plastic sense. Many modern artists have drawn inspiration from this strange art.

10. *The Court Jester 'El Primo'*
Velázquez
The Prado, Madrid
Velázquez loved painting portraits of jesters and dwarfs but not with any idea of ridiculing them.

In fact these extraordinary portraits, executed with technical perfection, succeed in telling us about the human and pathetic side of these misunderstood people. Their sad, dignified faces make us forget their physical deformities.

The beauty of this painting lies in the psychological understanding of the artist in his representation of the subject, thereby giving us proof of his human sympathy.

11. *Solidity of the Fog*
Luigi Russolo
G. Mattioli Collection, Milan
The choice of subject is a decisive factor in the originality of a work. The more compelling, the more original, the more interesting will be the result. Russolo aimed at expressing the substance of the fog and was successful. The picture is rather abstract but it is also descriptive and a fine composition.

12. *Sunflower*
Gustav Klimt
Parzer Collection, Vienna
Here is an attempt at decorative fantasy and 'preciousness' of execution. This type of painting, in which every inch of surface is covered, can be very effective. Imagination, invention and real originality went into the making of this unusual sunflower.

Art does not always consist of the inspired line or perfect brush stroke. Sometimes, as in this case, it is the fruit of patient decorative work.

13. *La Loge*
Toulouse-Lautrec
Ludwig Charrel Collection, New York
Painting provides us with a record of past periods. Toulouse-Lautrec was in particular a painter of the costume of his time. In his paintings appear types, settings and situations which give a true reflection of the world of this strange artist. The attraction of his work lies in the psychology of the people, in the depiction of costume and in the artist's inimitable technical virtuosity.

14. *Martyrdom of St. Bartholomew*
Ribera
The Prado, Madrid
The outstanding feature of this painting is the composition. It is not a static composition of the various elements, but a dynamic composition based on the movement of the figures. The position of each person has been accurately thought out on the basis of the predetermined lines of the composition. The result combines therefore two great qualities: movement and harmony. The typical Ribera chiaroscuro adds the third quality: force of expression.

15. *Still-life*
Jean Brusselmans
Gustave van Geluwe Collection, Brussels
The absence of perspective or anti-perspective is one of the most effective and commonly used devices for giving subjects expressive force. The artist does not embrace an ensemble but creates a composition with isolated elements from which he uses the angle or point of view that best describes them. Thus we see how the plate with the fish is viewed from above while the basket of potatoes is viewed from the front. The artist's sole aim is to describe what he is painting and for this purpose he exploits exaggeration and free perspective.

16. *Cyclists*
Feininger
Kröller-Müller Museum, Cologne
A subject can be treated from many aspects. Feininger has chosen movement as the main subject of a cycling circuit. In fact he has used the cyclists as isolated elements to make a composition of men and bicycles. Their aggressive, angular postures as they stoop over the handlebars increase the sensation of steep descent and therefore of velocity, action.

The Cubist style gives more formality to the composition.

17. *The Artillerymen*
Henri ('le Douanier') Rousseau
Guggenheim Museum, New York
Strange this beauty that Rousseau has created based on simplicity of composition, ingenuousness in the forms, meticulous treatment of details. You could take it for a child's painting, but how expressive is this military 'photograph' and how well it conveys the ingenuous and bewildered appearance of these youths so proud of their gun. This deliberate naïveté, genuine as it is, has great plastic value.

18. *Chapel of the Treasury of St. Gennaro*
Giacinto Gigante
Museum of St. Martin, Naples
To create works like this, it is necessary to be a complete artist—to be versed in drawing, painting, architecture, perspective, chiaroscuro, proportions, composition etc.

Such works are indeed a documentation of past times, and the fidelity to detail is beyond doubt.

* * *

You should now follow up this introduction to reading works of art with visits to exhibitions, galleries and the study of books containing reproductions of the most varied kinds of painting etc. What you must always avoid is running down what you fail to understand. It is a hundred times better to delve more deeply into these artistic messages that men from every part of the world have bequeathed to us throughout the long course of history.